SPEEDMASTER 38 MM

Blending iconic Moonwatch design with refined feminine style, the Speedmaster 38 mm is a popular choice with women across the world. Not only does it offer the classic look of OMEGA's most famous chronograph, it also enhances every detail with a rich combination of materials and colours.

Presented on a taupe brown leather strap, the elegantly sized case has been crafted in stainless steel and 18K Sedna™ Gold, with a dual bezel that is split between an aluminium tachymeter scale and a circle of sparkling diamonds.

Most captivating of all, the watch features a "cappuccino" dial with horizontal brown oval subdials, creating a soft and luscious effect that looks beautiful on any wrist.

The timepiece is completed with a precise Co-Axial Chronometer movement, which sits just behind a polished Seahorse medallion on the caseback - a further tribute to the Speedmaster's indelible history.

Ω OMEGA

KINFOLK
NOTES

(hand cream)

A new line of home and beauty products by *Kinfolk*, created to instil rituals and invite sensory pleasure into everyday life. Available at Kinfolk Dosan, Seoul.

MASTHEAD

KINFOLK

MAGAZINE
—
EDITOR IN CHIEF — John Burns
EDITOR — Harriet Fitch Little
ART DIRECTOR — Christian Møller Andersen
DESIGN DIRECTOR — Alex Hunting
COPY EDITOR — Rachel Holzman

STUDIO
—
PUBLISHING DIRECTOR — Edward Mannering
STUDIO & PROJECT MANAGER — Susanne Buch Petersen
DESIGNER & ART DIRECTOR — Staffan Sundström
DIGITAL MANAGER — Cecilie Jegsen

—
CROSSWORD — Mark Halpin
PUBLICATION DESIGN — Alex Hunting Studio
COVER PHOTOGRAPH — Romain Laprade

The views expressed in Kinfolk magazine are those of the respective contributors and are not necessarily shared by the company or its staff. Kinfolk (ISSN 2596-6154) is published quarterly by Ouur ApS, Amagertorv 14B, 2, 1160 Copenhagen, Denmark. Printed by Park Communications Ltd in London, United Kingdom. Color reproduction by Park Communications Ltd in London, United Kingdom. All rights reserved. No part of this publication may be reproduced, distributed or transmitted in any form or by any means, including photocopying or other electronic or mechanical methods, without prior written permission of the editor in chief, except in the case of brief quotations embodied in critical reviews and certain other noncommercial uses permitted by copyright law. The US annual subscription price is $75 USD. Airfreight and mailing in the USA by WN Shipping USA, 156-15, 146th Avenue, 2nd Floor, Jamaica, NY 11434, USA. Application to mail at periodicals postage prices is pending at Jamaica NY 11431. US Postmaster: Send address changes to Kinfolk, WN Shipping USA, 156-15, 146th Avenue, 2nd Floor, Jamaica, NY 11434, USA. Subscription records are maintained at Ouur ApS, Amagertorv 14B, 2, 1160 Copenhagen, Denmark. SUBSCRIBE: Kinfolk is published four times a year. To subscribe, visit kinfolk.com/subscribe or email us at info@kinfolk.com. CONTACT US: If you have questions or comments, please write to us at info@kinfolk.com. For advertising and partnership inquiries, get in touch at advertising@kinfolk.com.

WORDS
—
Fedora Abu
Precious Adesina
Allyssia Alleyne
Alex Anderson
Ellie Austin
Annabel Bai Jackson
Ariel Baker-Gibbs
Louise Benson
Katie Calautti
Rachel Connolly
Stephanie d'Arc Taylor
Daphnée Denis
Tom Faber
Yolanthe Fawehinmi
Selena Takigawa Hoy
Rosalind Jana
Laurs Kemp
Nathan Ma
Okechukwu Nzelu
Agnish Ray
Debika Ray
Asher Ross
Laura Rysman
Rowan El Shimi
Ricci Shryock
Emma Silvers
George Upton
Alice Vincent
Salome Wagaine

STYLING, SET DESIGN, HAIR & MAKEUP
—
Rebecca Alexander
Lucy Gibson
Helena Henrion
Jessica Lillico
Jèss Monterde
David Nolan
Giulia Querenghi
Stephanie Stamatis
Sandy Suffield
Helena Tejedor

ARTWORK & PHOTOGRAPHY
—
Sergiy Barchuk
Neil Bedford
Kieran Boswell
Cheyenne Boya
Luc Braquet
Maxime Cardol
Justin Chung
Marina Denisova
Ämr Ezzeldinn
Sean Fennessy
Carlota Guerrero
Dudi Hasson
Allyssa Heuze
Phillip Huynh
Cecilie Jegsen
Helen Koker
Kourtney Kyung Smith
Romain Laprade
Alixe Lay
Matthieu Loko-Bille
Inès Manai
Christian Møller Andersen
Dà Silvio Nkouka-Bizenga
Christina Nwabugo
Clément Pascal
Frank Perrin
Ben Richards
Melissa Schriek
Neige Thébault
Marsý Hild Þórsdóttir
Emma Trim
Gioncarlo Valentine
Yuna Yagi

PUBLISHER
—
Chul-Joon Park

vipp

Vipp Sculpture Lamp

Sculptural illumination

A new Vipp lamp hits the spotlight
and doubles as sculpture and ignited tool.

VIPP.COM

ISSUE FORTY-SIX

WELCOME
The Interiors Issue

In Copenhagen, where *Kinfolk* is based, we are entering the season of long nights, cold skies and at-home gatherings that feel smaller, cozier and more intimate. This turn in the season has prompted the magazine to take as its theme a subject that has been of perennial interest in the office, but which has never been explored in a dedicated issue: interiors.

It is a great privilege to be welcomed into the homes of interesting people. On behalf of our readers, Issue Forty-Six accepts invitations inside 10 extraordinary residences across five continents. You'll find remote farmhouses in Japan and England, modernist masterpieces in California and Australia, a guesthouse in Senegal, and two palatial European apartments reimagined in very different ways by their fashion designer occupants. What unites all of the homes is the intimate way in which their owners have shaped them.

For some, this has been a question of working with what was already there—Jorge Parra, featured on page 164, scraping away at layers of paint on the walls of his Spanish palazzo, or Sean Fennessy and Jessica Lillico, on page 98, tirelessly restoring the work of "bush modernist" Alistair Knox, whose suburban Melbourne homes were being razed by many neighbors. Other interviewees have been involved in shaping the blueprints right from the laying of the foundation stone. In Cairo, on page 118, we visit costume collector Shahira Mehrez's penthouse, which she commissioned from the architect Hassan Fathy over 50 years ago. It's an extraordinary example of a home that has not only been shaped by the vision of a single occupant, but which stands today as a beacon of local tradition.

Woven through other sections of the magazine, you'll find stories that delve into the twin issues of sociability and isolation that encapsulate the winter months. At the convivial end of the spectrum, we speak to party reporter Brock Colyar, who outlines what makes for a night to remember, and cook Deb Perelman, whose blog, *Smitten Kitchen*, has weathered the rise and fall of the format to remain one of the best-loved recipe sources on the internet. And for those who view winter as a season of withdrawal, you'll find short essays on the concept of "wintering" and the solace of nature, and a longer exploration of the renewed popularity of homesteading.

Plus, we have interviews with two very different, but equally fascinating, fashion designers—the British menswear designer Samuel Ross and the French couturier Charles de Vilmorin; a visit to the hangarlike studio of West Coast sculptor Yoko Kubrick; and a new column in the Directory in which we meet people working behind the scenes in the creative industries.

WORDS
JOHN BURNS
HARRIET FITCH LITTLE

HOUSE OF FINN JUHL

The Chieftain Chair

The iconic Chieftain Chair is one of Finn Juhl's absolute masterpieces, representing the peak of his career as a furniture designer. At its introduction in 1949, the chair marked a renewal of the Danish furniture design tradition.

Today, it is perceived as one of the most important exponents of the Danish Modern movement in the US during the 1950s. The chair is available in walnut or oak with upholstery in selected, exclusive leather types.

HFJ

www.finnjuhl.com

CONTENTS

20 — 48

STARTERS
Shortcuts through the zeitgeist.

20	Community Inc.	37	Clapping Conventions
22	Albert Hill & Matt Gibberd	38	Lil Silva
24	Plain Genius	40	Nothing Personal
25	Good Junk	42	Brock Colyar
26	Puff Piece	44	Natural Remedy
28	Future Proof	45	Brief Encounters
30	Hun Choi	46	Word: Wintering
34	The Kissfist	48	How to Get Rich
36	Consider the Mango	—	—

50 — 96

FEATURES
A chef, a sculptor and a streetwear icon.

50	Samuel Ross	72	Studio Visit: Yoko Kubrick
62	Home Sweet Homestead	78	Charles de Vilmorin
66	At Work With: Deb Perelman	88	Home Free

"This is a time of autonomy, and I want to leverage that." (Samuel Ross – P. 54)

14

ISSUE FORTY-SIX

marset outdoor

String shelving system made in Sweden. Reseller in your region: stringfurniture.com/find-a-store

≡string®

Modern since 1949.
Thousands of new combinations
yet to be discovered.

CONTENTS

98 — 176

INTERIORS
Worlds of color, craft and comfort.

98	Bush Modernism	140	California Cool
108	Gothic Revival	148	Seaside Studios
118	Cairo Calm	156	Rural Splendor
124	Cubist Cocoon	164	Faded Grandeur
132	Medieval Modern	170	Heritage Craft

178 — 192

DIRECTORY
Comment, columns and a crossword.

178	Peer Review	185	Last Night
179	Object Matters	186	Emanuele Coccia
180	Behind the Scenes	188	Cult Rooms
182	Crossword	191	Stockists
183	Correction	192	My Favorite Thing

THE TINY BIG SISTER

I

20 — 48

STARTERS
On mangoes, dance floors and clapping.

26	Puff Piece	38	Lil Silva
28	Future Proof	40	Nothing Personal
30	Hun Choi	46	Word: Wintering
36	Consider the Mango	48	How to Get Rich

COMMUNITY INC.
Can a brand be friends with its fans?

The stats keep telling us we're more alienated than ever. But online, we know, new spaces are always springing up to fill the void left by in-person connection. Increasingly, there's a company at the center of them, building up and cashing in on their so-called "brand community." Millennials want to feel "welcomed and included, and a part of something," Henry Davis, former president and CFO of beauty unicorn Glossier, said in 2018. "The brands of the future recognize that and make people a part of something."

Until you belong, brand communities are easy to miss—they're typically designed for the devotees rather than for casual consumers, and not widely publicized, if publicized at all. LEGO has its LEGO Ideas platform, where members can share custom creations, read interviews with fellow builders and submit proposals for new sets (a 1,969-piece model of the NASA Apollo Saturn V rocket and a *Doctor Who* scene are just two of the many fan designs to make it to production); while for years, Glossier maintained a private Slack channel where hard-core fans could connect with one another and discuss existing and future products. Since fast-food chain Wendy's launched its Discord for fans last year, it's amassed tens of thousands of active members, who share memes and fan art and talk about the menu.

It's hard not to put a cynical read on brands elbowing their way into the realm of human connection and capitalizing on the unpaid ideas, imagery and de facto promo copy generated by their consumers. For the majority of businesses, community is a one-sided concept, where all comments and content are directed toward The Brand, to be gathered, moderated and distributed on the company's terms. The price of membership can be as low as a one-time purchase or the use of a hashtag—bargain-basement brand engagement.

But not all brand communities are created equal. Successful examples—the ones that are broadly self-sustaining—are less about individuals talking to The Brand than about the collective experiences these forums facilitate. They connect members with each other.[1]

Besides, if official brand communities did not exist, it would be necessary for consumers to invent them. Before the launch of an official LEGO space in 2008, for example, fans congregated on sites like Brickset to rate and review sets and connect with fellow "AFOLs" (Adult Fans of LEGO). And more recently, Devin Ki'Elle McGhee started the Instagram account @GlossierBrown as a space for Glossier shoppers of color to share photos of the products on darker complexions and share tips. (McGhee later received a $10,000 grant from Glossier to start her own beauty brand.)

A brand doesn't even need to exist in the traditional sense to bring people together. After it was announced that Hedi Slimane was succeeding Phoebe Philo as creative director of Celine in 2018, hundreds of thousands followed the fan-created @OldCeline Instagram account that shared editorials, campaigns and street style photos featuring the garments from the French fashion house's "golden age." Commenters shared their memories and mourned together in the comments.

When they're effective, brands are less creating communities than formalizing them, using their resources to give their committed fan base another feature they actually want—whether it's a forum to suggest their dream products, or access to like-minded people who share their passion. With the brand footing the bill for the infrastructure, all it costs consumers to enter is their genuine enthusiasm.

(1) Netflix has been savvy about encouraging fan-created content for its shows. After the release of *Bridgerton*, TikTokers Abigail Barlow and Emily Bear created an unofficial musical version of the show with the blessing of Netflix and even won a Grammy for their album recording. However, the streaming giant drew the line at live performances, for which the musical's creators refused to negotiate a license. "What started as a fun celebration by Barlow and Bear on social media has turned into the blatant taking of intellectual property solely for Barlow and Bear's financial benefit," said show creator Shonda Rhimes.

WORDS
ALLYSSIA ALLEYNE
PHOTO
CARLOTA GUERRERO

ALBERT HILL & MATT GIBBERD

WORDS
GEORGE UPTON
PHOTO
MARSÝ HILD ÞÓRSDÓTTIR

From real estate to lifestyle titans.

It's been almost 20 years since journalists and childhood friends Albert Hill and Matt Gibberd founded real estate agency The Modern House. Combining their experience at magazines including *Wallpaper** and *The World of Interiors* with a passion for modernist architecture in the UK, they have grown The Modern House into an aspirational lifestyle brand, as well as a place for the very wealthy to buy property. A recently launched sister company, Inigo, caters to those whose preference is for historic homes.

As the pair explain here, they hope that the rich editorial content and magazine-style photography have also helped put Britain's architectural heritage on the map.

GEORGE UPTON: What's the concept behind The Modern House?
ALBERT HILL: When we started out, the real estate landscape was pretty barren and real estate agents had a bad reputation. Architecturally interesting houses were only seen in commercial terms; they weren't understood from a design perspective. We saw an opportunity to step in and offer something different and refreshing.
GU: How did your experience as journalists influence your approach to real estate?
MATT GIBBERD: There had always been a thrill in getting to see what's behind someone's door and discovering the way that they live, but there's only so far you can take that when you're writing an article. We were drawn by the idea that we could have a longer relationship with someone and their home while still taking a journalistic approach with research and beautiful photography.
GU: Do you feel like you've contributed to the status of modernist architecture in the UK?
AH: That was certainly the intention. We saw that these great modernist houses were unloved and undervalued and we've been able to shine more of a positive light on them.
MG: It's especially the case with the Span houses [postwar communities designed according to modernist principles]. They had been thought of as pretty standard and suburban but the way they interact with the landscape, the sense of community they foster, the sliding room dividers—it all adds up to a more nuanced and exciting experience. I think people have really come with us on the journey of discovering that.
GU: What characteristics make a good home?
MG: We hit upon five principles when we were writing our book, *A Modern Way To Live*. The first is space and whether it has been used intelligently. Then comes materials: We always say the easiest fix for someone buying, or even just renting, would be to change the objects you come into contact with every day—handles or kitchen worktops, for example. Light is the third principle: both whether there's enough natural light and the right quality of artificial light. And the fourth is nature: Do you have a good view or are you close to a park? Can you bring nature inside with flowers and plants? Lastly, there's decoration, which is obviously very personal but you should try to surround yourself with those things that have meaning to you and uplift you.
GU: Do you have any advice on what to look for when buying a property?
MG: You need to try and get a sense of the "bones" of the house rather than be distracted by the decoration that's there when you view it. Try to focus on the things that you can't do much about.
—

KINFOLK

WORDS
GEORGE UPTON
PHOTO
PHILLIP HUYNH

Christopher Columbus was at a party with Spanish nobles when he found himself having to defend his reputation. It was inevitable, he was told, that *someone* would have discovered the New World if he hadn't done so.

In response, Columbus asked for an egg to be brought to the table, and challenged the nobles to make it stand on its end. After they had all tried and failed, Columbus tapped the egg on the table, cracking the bottom slightly so that it did not fall over; demonstrating that while his idea was straightforward, the challenge was to think of it in the first place.

At least, that's the story according to the Italian merchant and historian Girolamo Benzoni, who was writing 60 years after Columbus' death. Another version, written by Renaissance biographer Giorgio Vasari, appeared 15 years earlier, this time attributing the moment of egg-cracking genius to Filippo Brunelleschi, an architect who was trying to prove why he should be chosen to design the dome of the cathedral in Florence. It was Benzoni's account that captured the popular imagination, however, and a brilliant idea that seems simple after the fact came to be known as "Columbus' egg."

The principle might be more relevant to some walks of life than others. Dr. Carl Djerassi, the scientist who first synthesized one of the key components of the contraceptive pill, dismissed his achievement because—when it comes to scientific developments—"most great inventions will be invented anyway." "A very different question is who wrote *Hamlet*," he added. "It would not have been composed if that person had not lived."

It's a point worth remembering if you ever find yourself looking at an artwork and thinking "I could do that." As the British artist Tracey Emin said, inadvertently paraphrasing Columbus in response to the critics who commented that anyone could have exhibited their unmade bed, "Well, they didn't, did they?"

PLAIN GENIUS
Most great ideas seem obvious afterward.

For anyone familiar with the spring-cleaning jetsam of a garage sale, the Marché aux Puces in Paris offers a cornucopia of delights. It is bigger and weirder, at once more general and more specific than the local thrift shop or church rummage sale. For three days a week, you can sift through keys for giant forgotten locks, dig into boxes of individual chandelier crystals or flip through paintings—some bad, some brilliant. Only a fool goes with a shopping list.

In his 1928 novel, *Nadja*, the surrealist artist André Breton described the Marché aux Puces as "an almost forbidden world of sudden parallels, petrifying coincidences, and reflexes particular to each individual ... flashes of light that would make you see, really *see*." Later, in *Mad Love* (1937), he recounted a walk there with sculptor Alberto Giacometti, who was in search of a head for a smooth elongated female figure, broken up between the knees and feet by a plinth, with elegant hands cradling a void. Giacometti happened across a squat metal fencing mask at one stall, which led to the creation of an angled, almost alien face comprised of huge saucer eyes, two slits for a nose and a triangular mouth opened in shock or awe. The extraordinary statue was first cast in plaster and photographed by Dora Maar in 1934.

Full of unexpected objects and juxtapositions, the flea market offered not only raw materials and artistic inspiration, but an embodiment of surrealism itself: an anti-art movement predicated on reuniting the conscious and unconscious realms of experience. A cast of characters selling a haphazard assortment of items rendered useless and bizarre by their decontextualization was itself surreal. At once familiar and strange, Meret Oppenheim's furred teacup (1936) and Man Ray's pony-tailed cello (1926, remade 1970) owe a debt to these trips to the hunting ground.

Susan Sontag credited Breton and his peers with creating a new way of browsing and buying: "upgrad[ing] visits to flea markets into a mode of aesthetic pilgrimage ... finding beautiful what other people found ugly or without interest." Other legendary markets such as the Chelsea Flea in New York have offered similar pleasures, attracting later generations of artists including Andy Warhol—another figure who venerated the everyday object, but who opted to treat as banal that which the surrealists saw as fantastical.

WORDS
ROSALIND JANA
PHOTO
SERGIY BARCHUK

GOOD JUNK
The artistic potential of flea markets.

PUFF PIECE
On inflatable art.

Conceptual art is sometimes accused of lacking substance. There is at least one particular field where the detractors would be, in a technical sense, correct: inflatable art.

Since the 1960s, artists have been exploring the potential to create sculptures that are at once monumental and fragile. Warhol's *Silver Clouds* (1966) uses a proprietary mix of air and helium to make a scene in which metallic pillows float lazily around a room. Anish Kapoor's abstract sculptures grow to fill vast spaces, inspiring a sense of awe and contemplation at their overwhelming scale.

Inflatable art can be playful too, channeling the nostalgic associations we have with blow-up objects and fun. Piero Manzoni's *Artist's Breath* (1960) consists of a balloon inflated by the artist, satirizing our fetishization of artistic production. Jeff Koons' giant balloon dog sculptures aren't technically inflatables—they're made from gleaming stainless steel—but engage audiences by subverting the preconceptions we have of such a familiar object.

Although seemingly insubstantial, inflatable art still has the power to shock. Paul McCarthy's 78-foot-tall *Tree* had barely been installed in Paris' Place Vendôme in 2014 when the artist was attacked because the sculpture appeared to resemble a giant butt plug (an allusion that McCarthy admitted was not entirely coincidental). Less than 24 hours later, *Tree* was sabotaged, deflating into a pile of forest green tarpaulin. The destruction triggered outrage from the French cultural elite and the then-President François Hollande: a very different kind of "Pop Art."

WORDS
GEORGE UPTON
PHOTO
MELISSA SCHRIEK

STARTERS

FUTURE PROOF
How not to become a cultural dinosaur.

WORDS
ANNABEL BAI JACKSON
PHOTO
INÈS MANAI

In the winter of 1949, the Whitney Museum in New York held its annual exhibition of American painting, a show whose curators aimed to forecast where modern art might go next. Given the undertaking, reviews were bound to be mixed. The *Time* magazine reviewer was particularly vitriolic: "If their sort of painting represented the most vital force in contemporary U.S. art," the critic wrote, then "art was in a bad way." The 21st century couldn't disagree more. The twin targets of the critic's flak, the "duds" as he put it—were Jackson Pollock and Willem de Kooning—now heralded as defining visionaries of abstract expressionism.

It is easy to dismiss the reviewer as naive, or as a conservative disposed to begrudge the avant-garde. But recoiling at the new is an instinct we all share. If we can't quickly assimilate an artwork into our codes of "good" or "bad," the impulse is to denounce it. You may have devoured the pages of *Mrs Dalloway* in 1925—but you may just as well have been the reviewer professing this radical text a "positive injury to art" itself. The same goes for 2022: *The Guardian's* Jonathan Jones recently tore into a digital art exhibition, calling the experimental mix of VR installations, laser work and electronica little more than a "pretentious nightclub where no one dances." He felt that this was not, as promised, "the art of the future."

Nobody wants to be on the wrong side of cultural history. So how can you keep your wits about you when confronted with the unfamiliar? When your gut reaction is hostile, start by asking a simple question: Do I dislike this artwork because it's bad, or because it challenges my idea of what art "should" be? Both the *Time* reviewer and the Woolf critic suffered from the same kind of premature nostalgia for what art "is." Pollock and Woolf hadn't just made bad art—they'd *hurt* it—and the critics wanted their old definitions back.[1]

If we're going to check ourselves in this way, we need to rethink the kind of attention we give to new art. French philosopher Simone Weil comes in handy here, with her model for encountering the other: "Our thought should be empty, waiting, not seeking anything," she writes, "but ready to receive" the "naked truth." *Receiving*, instead of *seeking*, helps us set aside our prejudices. We're already exposed to the knotty politics of taste-making—the derisory tweets and viral articles that currently shape the canon. But if we can stop hunting out evidence of the "good" or the "bad" when approaching a new artwork, a rarer, more generous assessment might arise.

What you may find, then, is that fledgling movements never emerge fully formed, and new trends representing "bad" art—hyperrealism, crypto art, Twitterature—are never as much of a lost cause as they seem. Being empty and "receiving" means recognizing opportunities even in the inane, or acknowledging where a movement's authentic spark got muddied. With Weil in mind, I try to suspend the urge to see new pieces through the lens of suspicion, or to use them as a prognosis for art's potential decline. I temper my knee-jerk response, which forms an opinion before I even know I have one. Now, even NFT art, which often reeks of a certain faddish cynicism, seems less shallow to me—and more representative of a high-tech iconoclasm that could one day win out.

You don't always have to come down on the side of the artist. In fact, in aiming for authenticity, an open mind itself can help whet the tools of critique. But this isn't the end of history; the new will always come. Let's make sure we're ready to receive it.

(1) Critics are not always a conservative force. In the 1960s and '70s, Brutalist buildings that appeared groundbreaking and daring to critics felt cold and hostile to many of those using them day to day.

STARTERS

HUN CHOI

WORDS
TOM FABER
PHOTOS
MAXIME CARDOL

DJ Hunee outlines his dance floor philosophy.

To see Hun Choi DJ is to witness someone who truly loves what he does. Where many DJs playing festival stages stare stonily at their equipment and relentlessly pump out high-octane club music, Choi is just as likely to take the energy down to a simmer with a mellow jazz number as he is to play a disco classic and whip off his shirt, beaming, to dance along with everyone else. His sets have an exploratory quality, so to be in his crowd is to feel as if you're all embarking on a musical journey together. Born to South Korean parents in Germany, Choi rose in profile over the past two decades as a superb DJ under the stage name of Hunee (pronounced who-nee, a nickname used by family and friends). He's lauded for his skills as a "digger," meaning he has a knack for finding obscure and rare music. Now based in Amsterdam, Choi DJs full time and when we talk, he's in the middle of a busy summer festival schedule. On a day off, he arrives to our video call dressed in a loose Japanese jinbei robe, freshly showered after a run and in a particularly reflective mood.

TOM FABER: Is DJing fundamentally about what songs you play or how you play them?

HUN CHOI: It's much less about the single track and more about finding the right context for the music to invoke an emotional journey in the listener. It's the same as in language—most people read a nice book and they're like: "Okay, I know all these words, I could write all these words," but it's about writing them in the right order. I'm fascinated with the formal and structural ideas around DJing. How can you tell a story with music, creating a narrative that includes dynamics like tension and release, anticipation, patience, high and low energy, light and dark, colors and emotions?

TF: Is there a particular way you think about each song within the space of a set?

HC: Sometimes I think of them like characters in a story. How will I introduce this, say, very tragic character, who's a little bit broken? How can I create a moment, a context, in which this song can come alive?

TF: Where do you go to find new music that excites you?

HC: A lot of it is through sharing music with friends. Random YouTube algorithms. Of course going to the record shop once a week. Then I also discover things in my own collection. I've been buying records for 20 years now and in this mode of consumption you amass a lot of music. In recent years I've taken more time to go deeper into the music that I have, returning to things that maybe I wasn't able to play in the right way when I was younger.

TF: When you're choosing music to play, is there something particular you're looking for?

HC: I always look for a human element, something that makes me feel alive and also feels alive in itself. I love when music feels like it's breathing. That doesn't just mean someone breathing into the microphone, it could also be a hypnotic techno track.

TF: How do you know what's the right song to play next when you're in front of the crowd?

HC: It's this weird split. You need to be in charge and exercise a certain degree of guidance, but also I really identify with the

crowd—my background is as a club kid dancing as well as a bedroom DJ. I recognize when I go into a club that there are so many different people there with different intentions, so I always try to first get people into the same emotional space, where they feel present and can connect with each other. Sometimes a DJ set can become its own animated being—something that breathes, feels alive and has its own forward motion. When that happens I'm like, "Okay, this was a good set."

TF: Can you tell me more about a DJ set becoming, as you said, "its own animated being"?

HC: You can be in many different places in a few hours and different eras as well. The perception of time itself can be modified and accelerated or slowed down. Surely you know the feeling of dancing to a good set and two or three hours pass like nothing. I think this is part of why it can feel magical, because it transcends space, time and maybe also your own idea of yourself.

TF: Are there common misconceptions about being a DJ?

HC: People don't realize that DJing itself is the smallest part of your job. The biggest part is admin and traveling. Another misconception is that people have this '90s rock star DJ image, whereas from my own experience and that of my friends, it reminds me much more of an athlete's lifestyle. When you DJ at a certain level, everything in your life is working towards you being able to maintain this schedule. It also says a lot about maybe how unhealthy the DJ job structure is.

TF: Is it ever nerve-wracking to be up there in front of the crowd?

HC: The first times I was on bigger stages with lots of people looking and pointing their phones at me, I felt so awkward. I just wanted to hide. But I learned that I have to first use music to create a space around me that I can really feel safe in, which means playing music that I actually love. I don't necessarily seek out the public limelight, so I enjoy that as a DJ you can disappear behind the music and all that matters is what you do with the decks.

TF: Are there other aspects of the industry you feel conflicted about?

HC: I do wonder with festivals and the environmental crisis: Is what I do still net positive? Sometimes I walk around a festival and I can appreciate the escapism of this alternative reality, but you also see decadence in it and the destructiveness and exploitation of this industry. They literally put a new place on the map. Suddenly EasyJet's flying there and thousands of people are going to go. Some parties do feel like industry and they're not built around creating magic on the dance floor, but instead churning through a system, generating a next edition which will be even bigger. You can feel the machine in everything.

TF: Given all that, do you still find the dance floor a magical place?

HC: Well, the night itself can still often be magical because we have so few other opportunities in life to publicly gather. I love to be in a place where people come in and perhaps for three or four hours they don't feel like a consumer. They feel beauty, maybe, and this is still valuable. Because otherwise we have so few spaces to even meet other people, to serendipitously form new encounters that are not defined by a digital interface.

TF: It's as if when you DJ you open up a space of possibility that allows for unexpected chemical reactions between people.

HC: It really is. I've been told many times about people who met and fell in love at one of my gigs. Some even got married and had kids.

TF: How does that feel to hear?

HC: I just think it's beautiful. When I play music, I want the space that gets created within the night to feel very open and communicative.[1] In our world, with the loneliness crisis, it's important to have a space where it feels like you can lower the threshold to just connect with other people.

(1) Choi often speaks about his sets in these terms. In a 2015 tweet that became a talking point within the industry, he wrote, "I never think of 'killing' or 'smashing' or 'destroying' it when I play music. I am searching for another relationship with the dance floor."

KINFOLK

THE KISSFIST
On the rich humor of sign language.

WORDS
ARIEL BAKER-GIBBS
PHOTO
CECILIE JEGSEN

According to pragmatics linguists, you tend to be around five or six years old when you start to understand that saying things opposite to the self-evident truth can be funny. Hearing people or people who use their voices automatically associate this with drawls, deadpan monotones or emphasized intonation. The same thing happens in sign language. Irony isn't just auditory, after all—it's also in facial expressions and body language. The face easily shows excessive excitement or flat affect, and equally common is the tongue-in-cheek flourish of some signs or a mock-serious leaning in and furrowing of the brows as someone says *"Really?!"* Given that facial expressions are a natural part of the grammar of any signed language, it requires a certain understanding of what the person means or the context. It feels like a secret treasure.

There are a handful of common phrases in American Sign Language (ASL) that have attained almost permanent ironic meaning.[1] One of my favorites is "kissfist you." The best straight definition of "kissfist" would be "something you love or enjoy," and the sign is literally kissing the back of your fist as you shoot it forward into the space in front of you. People learn kissfist in ASL 101 to sign that they love basketball, say, or reading. But when applied to people, as in "kissfist you" or "kissfist them," ending with a finger pointing at the relevant person, it is almost always ironic. It becomes "I find this typical ongoing behavior deeply entertaining (what a dumbass)." This can fall anywhere on the range from eye-rolling affection to laughing scorn.

Hearing people do not expect Deaf people to be ironic. We are perceived to be simple and naive because what we are saying cannot be heard, and nor do hearing people expect us to mean what we really mean. But irony is everywhere in conversations among ourselves, and in how we observe the public situations we find ourselves in together. Someone gets angry at us for not hearing them tell us that we are sitting in their seat, then it turns out that seat was not theirs. Kissfist self-righteous random hearing person. Our interpreter dramatically stops a simple conversation because they don't understand what's going on and they *need time!* Kissfist interpreters. A friend of ours thought they could get away with it, whatever *it* is. Kissfist them, too.

Most of the time, "kissfist you" comes from a place of intimacy. We say we kissfist this person because it means that they're a fixed part of our experience—either as someone we frequently encounter out in the world or as a permanent member of our community whose presence we accept and even find some glee in. The Deaf community is small and we go through a lot just to find communication. A vast majority of us are born to hearing parents with no prior knowledge of sign, and only a small portion of our parents make the effort to learn sign for us, to surround us with language we don't have to labor to access. Others of us are born to Deaf parents or grandparents whose hearing parents didn't learn.

Irony is tacit shared understanding and saying the opposite *on purpose*. It depends on early language development, cultural awareness and a sense of belonging. So we cherish our sense of irony: It's embedded in our language.

(1) Irony can also be indicated by fingerspelling a word out, rather than using the sign that symbolizes it. Baker-Gibbs has written about this before for *Activating Captions*, explaining that "There is a staggered spatial completeness that happens with fingerspelling in these particular situations, a forcing of the listener to wait, to take the time to pay attention to the word that the speaker chose, to its irony and ideological frailty."

In 1968, during the early days of the Cultural Revolution in China, Pakistan's foreign minister, Mian Arshad Hussain, presented Mao Zedong with a crate of mangoes. At a moment of grave instability in his country, Mao sent them on to the factory workers he had deployed the previous week to intervene in a bloody clash between students at Tsinghua University. The move suggested he was bestowing the gift of long life onto the recipients, thus elevating the unfamiliar fruit to quasi-holy status.

Over the next year, the recipients bowed to and caressed them, preserved them in formaldehyde or wax, or boiled them to create a sweet sauce to sip one teaspoon at a time. A poem published in *People's Daily* read: "Seeing that golden mango/ Was as if seeing the great leader Chairman Mao." Mango merchandise proliferated and detractors were punished for not respecting the fruit.

In China, this obsession lasted only 18 months, but the cultlike worship of mango is not unique to that time and place—the real mystery is why it ended. This fragrant treat, most commonly grown in South Asia, is abundant in myths and art. It's the national fruit of India, Pakistan and the Philippines and the national tree of Bangladesh. For those who have grown up in these regions, mango season brings on madness: A yellowy-orange mist clouds all thinking. Soon, you find yourself in a fevered frenzy to consume them all before they rot—standing over a sink, thick juice dribbling off your elbows, gorging on the sweet flesh of yet another until the acid burns your stomach and stings your mouth.

In 2014, when the European Union temporarily banned the import of alphonsos (the king of mangoes) over concerns about food standards, it caused an uproar; a petition calling for a reversal attracted hundreds of signatures. In the US, where Pakistani mangoes are hard to come by, a shady informal network has emerged on WhatsApp to help addicts get their fix. And this year, a couple in India hired four security guards and guard dogs to protect their crop of rare Japanese Miyazaki mangoes, which retail for over $50 in the US.

In the West, many people remain blissfully ignorant as to the mango's magical qualities, which is as inexplicable as it is cheering; fewer competitors means more mangoes for the rest of us.

WORDS
DEBIKA RAY
PHOTO
HELEN KOKER

CONSIDER THE MANGO
An ode to the world's sweetest fruit.

"Let's hear a round of applause for...!" We've all heard and complied with this request, clapping as a singer, keynote speaker or graduating class walks on stage. This welcoming applause might sound much like any other—the applause that comes after an event, or sometimes during—but it carries a different message.

Discourse analysts categorize applause as introductory, closing or rewarding. In most public events the first two of these are essentially obligatory: It would seem rude not to clap a symphony conductor onto the stage, or to sit silently as actors bow after the curtain call, even if we didn't enjoy the performance. Spontaneous "rewarding applause," in contrast, expresses the flow of the crowd's reactions. Athletes win raucous acclaim with great feats on the track or field. Politicians gain approval by using "applause lines," after which they pause in anticipation of at least a few clapping hands.

Most events carry implicit, reasonable protocols for delivering applause: No clapping in a church service, to preserve a sense of solemnity; hold applause until the end of a public lecture, to avoid disrupting the flow of ideas; never clap after individual movements at the symphony, only at the end. These "rules" are not always firm, however, and spontaneous applause tends to follow what cognitive scientists Gary Lupyan and Ilya Rifkin have termed an "embarrassment threshold," which varies with forms of art and entertainment and the crowds that participate in them. At any public event, you can clap when you want, despite the rules, but others may not follow along. Then you'll be left alone with the rest of the crowd listening until you give it up. Alternatively, if you can stick with it and someone else joins in, a cascade develops until everyone feels compelled to clap too, and a round of applause begins.

This cascade helps bridge the divide between audience and performers. The applause does more than encourage effort, it allows the crowd to join the course of the event and commune with its players.

WORDS
ALEX ANDERSON
PHOTO
H. ARMSTRONG ROBERTS

CLAPPING CONVENTIONS
A handy guide to applause.

LIL SILVA

WORDS
YOLANTHE FAWEHINMI
PHOTO
CHRISTINA NWABUGO

A superstar collaborator steps into the spotlight.

You see him. You cannot miss him. Lil Silva is near six feet tall and moves with the certainty of a man who isn't afraid of his potential. The 32-year-old British Jamaican producer, singer, songwriter and DJ was raised in a musical home in the south of England where propulsive reggae, funk and jazz rhythms played alongside hip-hop and garage. He spent most of his childhood sitting behind his home PC creating beats, or harmonizing with the church choir before becoming a regular at the old Cabana Club in Bedford. Tyrone Jermaine "TJ" Carter (his real name) has since worked with many collaborators—Banks, Adele and Mark Ronson among them—and recently released his debut album, *Yesterday Is Heavy*, which unveils a decade's worth of musical influences and friendships.

YOLANTHE FAWEHINMI: You've taken your time thinking about the type of music you want to put out into the world. What was it like seeing collaborators have their moment in the spotlight?

LIL SILVA: I actually made a song about this called "Always Wonder." Just because people are publicly doing what they're doing, it doesn't mean I'm not doing it too. I've been trusting the process more, because the expectations can be overwhelming.

YF: The way songs are structured takes listeners on an emotional journey. What would you say is the most boring or difficult part of being a producer?

LS: When it comes down to mixing and stems [audio files that break down a track into its constituent parts], I tell myself that I love doing it. It's super long and is going to take up half of my day. Sometimes I'll order some Chinese and drink red wine, so I can enjoy the moment. It's about reversing your mindset.

YF: You've spoken about how every song on the album has a favorite moment. Are there any lyrics that really resonated with you?

LS: The album was centered around peace, hope and happiness. "Colors colors colors" was the riff that wouldn't leave me for a good week. There was so much going on at the time, including the murder of George Floyd. I was quite angry and fell back into my gritty basses. We live in a world where we can do beautiful things, but because of the negative energy we put out, things won't change. I also loved when Elmiene said "Your faults are your way to the future" in "About Us." I put that on a T-shirt.

YF: I want to talk about your relationship with Virgil Abloh. Are there any lessons you learned from him?

LS: You learn so much from a man like Virgil. I met him at XOYO [a nightclub in London] and the collaboration was the fruit of a lot of back and forth. I was sending him all my exclusives and the energy he was coming back with was encouraging. He suggested that we design a T-shirt and vinyl for the music we were releasing. He was in his own lane of creativity. Look at all he has done for creators and the world of fashion.

YF: Is image important to you?

LS: I mean look good, feel good. Silva has his own look! It's cool, laid-back and super chilled. Duval Timothy only wears blue and I just started to wear black. But it got louder at some point. Especially my pants. Maybe I *do* have a style.

NOTHING PERSONAL
It's okay to keep it professional.

Among companies with a conscience, there's a fashionable notion that employees should be bringing their "whole selves" to work. The whole self is vocal with feedback and generous with personal stories. The whole self is bursting with low-level quirks and surprising interests. And the whole self is honest about their struggles and patient with their colleagues, because we're all friends here, right?

The concept of bringing one's "real" self to work was popularized in 2015 by the author and speaker Mike Robbins, who implored viewers of his much-watched TED Talk to "embrace vulnerability and to let go of our attachment to what other people think about us." It's a lovely concept, this idea of just being yourself. But don't fall for it. You don't owe your boss your personality, and the risk of baring it all can far outweigh the rewards.

First, the obvious reason. Everyone has good traits and bad traits, not all of which our colleagues want or need to see. While the occasional bout of mild anxiety or flightiness may be tolerated, companies are typically not inviting employees to appear misanthropic, bored, depressed, disengaged or just in it for the check. What passes for professionalism is often performance, and there have been decades of research looking at the pervasiveness of self-modification for the sake of security. In 1963, sociologist Erving Goffman coined the term "covering" to describe the efforts of people from marginalized groups to downplay their differences to avoid being stigmatized by the dominant group.[1] "Code-switching" is also a commonly used term to describe the act of adjusting one's mode of speaking based on context, something that people of color often do.

It's understood that authenticity will not protect you from being stereotyped, undervalued or persecuted, and that the privilege of being yourself is not always evenly enjoyed. In their book *Beyond the Gender Binary*, Indian American artist Alok Vaid-Menon summarizes this tension: "They tell us to 'be ourselves,' but if you listen closely, there's more to that sentence: '…until you make them uncomfortable.'… There is always a limit. A breaking point. Once you cross the line, then you are 'too much' and are put back in your place."

In a Deloitte survey, 61% of employees reported downplaying a part of their identity "due to fear that they'll be discriminated against or seen as not taking their work seriously enough." And while the numbers were higher among groups that were underrepresented—including 79% of Black people, and 83% of lesbian, gay and bisexual people—nearly 50% of straight white men reported doing it too. This, of course, isn't ideal. And while it's hard for companies to address issues their employees are reluctant to discuss, most companies—even good ones—do not offer the amount of safety that people require to actually be vulnerable.

The onus, then, is on companies to create an environment where people feel free to share as little or as much of themselves as they choose. In LinkedIn lingo, this is known as ensuring psychological safety—the feeling that you can speak out, push back and open up without the risk of punishment or humiliation, whether explicit or indirect.

Actions speak louder than buzzwords. Generous parental leave policies, for example, may encourage parents to be more frank about their struggles with childcare; while a diverse C-suite and targeted hiring and retention strategies may show people that difference is valued. When employees feel secure in their position and supported for who they are, they may not bring their whole selves to work, but there's a better chance they will bring their best.

(1) "Good cultural fit" is a term often used by recruiters to describe desirable personal attributes that don't relate to the job description. While this may be reasonable in certain circumstances—someone wanting a nine-to-five will not appeal to a three-person start-up—it is often a means of discrimination. For example, older candidates may be dismissed as a "bad fit" for the same start-up simply because of their age.

WORDS
ALLYSSIA ALLEYNE
PHOTO
ALLYSSA HEUZE

41

KINFOLK

STARTERS

BROCK COLYAR

WORDS
NATHAN MA
PHOTO
EMMA TRIM

An interview with a professional partygoer.

What makes a great party? Brock Colyar is trying to figure it out. The 24-year-old party reporter joins New York's club kids for an evening out, then breaks down what they saw and how they felt in "Are U Coming," a newsletter for *New York Magazine*.

With curiosity and humor, Colyar captures the breadth and range of nightlife and the people who love it. Their profiles push the possibilities of partying to its outer limits, and they've tagged along with Blockchain bros, international pop stars and even nightlife legend Susanne Bartsch. But when we speak, they're at home in Brooklyn enjoying something of a rarity in their line of work: It's a Friday morning, and they're getting ready for a weekend of rest.

NATHAN MA: What was the inspiration for "Are U Coming"?
BROCK COLYAR: As the city started to reopen, we knew nightlife was going to flourish again, and wanted a unique way to cover its return. But there's so many different types of nightlife in New York, and the newsletter is a way for us to get into as many of these environments as possible. I think people can be precious about their nightlife spaces, so the inspiration was always Anthony Bourdain for me: He went to other cultures with a tour guide to show him the local fare, or in my case, the local nightlife. Anthony Bourdain was really good at going into a culture, but not trampling all over it. He put his own thoughts and spin on it, but didn't intrude too much.
NM: What's your go-to icebreaker for meeting people at parties?
BC: The question I ask people is, "Are you having a good time?" It's the easiest way to start talking to someone at a party because either they're going to tell you they're having a great time or they're going to tell you they're having the worst time ever; and bonding over shared happiness or misery is always a good thing.
NM: How can we throw better parties?
BC: Just get really fun and creative and sexy. One of the best parties I went to when the city was coming back was thrown by a group of 20-something kids from Brooklyn, mostly queer and people of color. They threw this Baroque-themed rave in an abandoned mansion in Long Island City. Everyone dressed up *Bridgerton*-style with hoop skirts and white makeup. When you walked in, they had string instruments playing. It was a truly unique and original idea, and people always love to get dressed up for something.
NM: You report on subcultures and mainstream parties alike. Where is the line between the two?
BC: Hand-wringing over when and where something goes from underground to aboveground is almost always futile. There will always be something new happening underground; anything that's good will go mainstream and people you don't want at the party will come. But that's inevitable. That's also what people want when they go out: People want to feel like they are special, or that they're doing something unique.
NM: When is the party over?
BC: The real lesson is that the party is really never over because there's somewhere else to go. I always feel bad when I get to the end of a night—I'll be ordering a car and thinking about how the party is going on somewhere else, and how I should probably try to find it. But sometimes, I have to sleep.

NATURAL REMEDY
The quiet companionship of plants.

The lonely have often found comfort outdoors. In *The Living Mountain*, an unfussy meditation on Scotland's Cairngorm mountains, Nan Shepherd writes: "Often the mountain gives itself most completely when I have no destination, when I reach nowhere in particular, but have gone out merely to be with the mountain as one visits a friend with no intention but to be with him." Shepherd never married; her ambiguous relationship with philosopher John Macmurray remains the only love affair in her biography. But amid the rough beauty of the Cairngorms, she found a rarer sort of companionship.

Few of us live near such magnificent landscapes, nor are surrounded by so few people, but taking a Shepherdian approach to our surroundings can quell the loneliness that arises even among those living in cities. I moved during lockdown, and sought connection with my new neighborhood while feeling distant from my loved ones. But in exploring the streets I found new little landscapes to ground myself in: the towering Echiums that arise from a neighboring front garden, the Sarcococca in the park I could smell from five paces. No mountains, but these plants are small friends I see changing with the seasons; to check in on and enjoy as a part of a community.

Whether in a small park in the city, or in a sprawling landscape far beyond it, there is so much to be found outdoors. There may be an absence of people, but pay attention and you'll see more-than-human life everywhere: The sound of the wind caught between branches, or a glimpse of the passing of the clouds. Birds flying, eating, singing. Insects going about their business. To witness these creatures interact with the plants, themselves part of an enormous, often unseen web of connectivity, is to realize that we are part of this world too: not cut off or isolated, but in communion with something far bigger than ourselves.

WORDS
ALICE VINCENT
PHOTO
CHEYENNE BOYA

BRIEF ENCOUNTERS
How to compliment a stranger.

WORDS
OKECHUKWU NZELU
PHOTO
NEIGE THÉBAULT

The urge to compliment strangers is pretty universal. You see someone on the train with a band T-shirt you love: great choice! You clock that a dress has pockets: good find! There's a particular joy in passing on these compliments; the delight on the stranger's face is a gift you both receive.

But there is a line to be aware of—that which separates kindness from intrusion. Most of us err on the side of caution, for fear of being woefully inappropriate. A colleague once confessed to me: "Whenever I'm jogging and I see anyone jogging toward me I always want to high-five them and say they're doing really well, but I never do." She was afraid of being ignored, but she was also conscious of boundaries.

Most of us appreciate a genuine compliment because it's gratifying to feel seen, especially if we've gone to any effort, whether that means putting together an outfit for work or going the extra mile on a jog. There is a special kind of pleasure in realizing that the bubble in which we move through life isn't as impermeable as it might seem.

While we might enjoy feeling seen, few people want to feel scrutinized or, worse, surveilled. Catcalling, for example, centers parts of us that we would rather not be publicly discussed by strangers: Rather than celebrating, it exposes or even threatens. It's about a power imbalance, not a connection between equals.

A compliment to a stranger works best when it is respectful and maintains an appropriate distance: It is usually nonsexual, uplifting and (this is key) easy to walk away from.[1] It asks for nothing because it conveys appreciation rather than desire. So high-five that jogger if you (both) want to. Just keep your hands where we can see them.

(1) Many pickup artists—the name given to men who coach others on how to approach women—offer the opposite advice, encouraging neutral questions or compliments before taking the conversation in a more flirtatious direction. Pickup artists were very influential in the decade following the 2005 publication of Neil Strauss' *The Game* and this legacy of distrust is likely part of the reason why it is difficult to compliment strangers without feeling creepy.

46

STARTERS

WORD: WINTERING
When to withdraw from the world.

WORDS
ASHER ROSS
PHOTO
DUDI HASSON

Etymology: To *winter* means to stay or reside in a given place through the coldest season of the year. It also refers to the act of preserving something through those months. Gardeners do their best to winter their cauliflowers, and grandparents winter in Palm Beach. The word was given new meaning by author and journalist Katherine May in her 2020 memoir, *Wintering: The Power of Rest and Retreat in Difficult Times*. In her metaphorical usage, wintering refers not merely to surviving a difficult period, but to "the active acceptance of sadness."

Meaning: In May's words, winter is "a fallow period in life when you're cut off from the world, feeling rejected, sidelined, blocked from progress, or cast into the role of an outsider." At certain times, often after disruptive life events, the things that we rely on for meaning—our job, our family, our ambitions, our favorite pleasures—can suddenly feel thin and remote. We are left with a sense of having become illegible to ourselves and to the outer world.

Ignore these feelings at your peril, says May. Our inner lives do not conform to an upward trend toward ever higher satisfaction and self-realization. Like the seasons, they are cyclical. Wintering is a choice to stand up and say, "I'm not okay, I no longer understand myself, and I must be alone." In order to winter, we must give up our attempt to keep our head above water. It's a brave thing to do.[1]

It's worth noting that the condition May describes is difficult to distinguish from depression, and it can be dangerous to attempt to resolve chemical depression in isolation. Still, May's concept of wintering shares important characteristics with psychotherapy, particularly in its determination to forgo distraction and confront difficult emotions.

May's memoir recounts a particularly long wintering in which she follows the faint melody of her feelings wherever they lead. She resigns from her academic post, she wakes at 4:00 a.m. in order to read poetry by candlelight, she swims with her son in the frigid waters off Iceland. Over time, with the white noise of her professional life silenced, she begins to recover, like nerves slowly reconnecting in an injured spine.

Wintering takes its cue not from the social world, but from nature. There, life withdraws during the cold months, conserving energy and preparing for regeneration. It is also a very quiet season. In a snowy field, the sound of a crow landing in an elm may be the loudest thing heard for hours. We all need such a place, from time to time: a place in which there is nothing to hear but ourselves.

(1) May has expanded the book into a successful podcast series, *The Wintering Sessions*, in which she and guests, such as author Cheryl Strayed, share their wisdom on enduring difficult times.

WORDS
SALOME WAGAINE
PHOTO
KIERAN BOSWELL

Vacations to private islands, the freedom to purchase luxury goods and having a chef on site at your holiday home: Money is the gateway to a glamorous lifestyle. But while the trappings of riches can be dazzling, the most reliable routes to obtaining them are far less alluring.

Some ways of getting rich quickly are time-tested. Marrying "well" is always a sensible option; in 2016, Italian economists found that high net worth households in 21st-century Florence were descended from the same families that paid the most tax in the city in 1427. Basing your prosperity on capturing the heart of a member of a prominent dynasty is imprudent, however. The unfortunate truth is that work, rather than courtship, might be your best bet.

What kinds of jobs earn the most? It can be tempting to envision achieving success as a bestselling author, not least because becoming a novelist has a relatively low barrier to access compared to corporate law or software development—and does not involve the stress of managing budgets or teams of employees. However, ownership, rather than creativity, is a faster track to financial success. Perhaps surprisingly, running an auto dealership franchise or a beverage distribution company in the US is one of the most lucrative routes available. In a country that prizes homeownership as a sign of "making it," property development also ranks high.

Consider RuPaul, the world's most famous drag queen. His career is down to a combination of charisma, uniqueness, nerve and talent—and savvy business acumen. Together with his husband, RuPaul now owns a 60,000-acre ranch in Wyoming and in March 2020, he sparked some controversy over its potential uses. He told *Fresh Air* host Terry Gross that his approach to land management was "[you] lease the mineral rights to oil companies and you sell water to oil companies, and then you lease the grazing rights to different ranchers." Many listeners interpreted this to mean that he was engaged in the controversial extraction method known as fracking. The most effective ways of multiplying wealth tend to be unglamorous—even for celebs.

HOW TO GET RICH
A disappointing treatise on wealth.

II

50 — 96

FEATURES
Couture, cooking and culture.

50	Samuel Ross	72	Studio Visit: Yoko Kubrick
62	Home Sweet Homestead	78	Charles de Vilmorin
66	At Work With: Deb Perelman	88	Home Free

Words
FEDORA ABU
Photography
NEIL BEDFORD

Samuel

KINFOLK
NOTES

kinfolk.kr @kinfolk_notes

KRUG

CHAMPAGNE

Krug Champagne ©2022, Imported by Moët Hennessy USA, Inc., New York, NY. Please drink responsibly.

Explore more at CARLHANSEN.COM
or visit your nearest Flagship Store

Dining · Hans J. Wegner · 1949–1965

A LEGACY OF CRAFTSMANSHIP

The reassuring feel of natural materials and the loving touch of expert hands are evident in Hans J. Wegner's designs. Since 1949, Carl Hansen & Søn has produced a wide range of Wegner's most iconic chairs and dining tables with the trademark care and uncompromising commitment that has distinguished us for more than a century. With each timeless piece, a new standard for modern furniture design is set.

CARL HANSEN & SØN

Useful Objects

Handmade Designs in Resin

tf

tf.design

ROSS

Art, fashion, lifestyle: SAMUEL ROSS has seen the future and it's got his name all over it.

Samuel Ross sees himself first and foremost as an artist. Not in the immaterial, overused sense of the word—but as a good old-fashioned paint-on-canvas artist. In his industrial-style office space in London's Brutalist cultural center 180 The Strand, he's offering me a privileged preview of a handful of his paintings in the abstract expressionist vein on his MacBook. Ross is currently in talks with a big-name London gallery about representation, and another has expressed interest in a collaboration of sorts. This latest venture isn't simply a box to tick on his growing list of creative pursuits. "If it were up to me, I'd be up a mountain in Guangzhou as a lay monk, just painting," he says. "I'd be on my Frank Bowling vibes."

But these days, 31-year-old Ross has far too much to be getting on with. Raised at the right hand of the genre-defying Virgil Abloh, he belongs to a class of creatives who flit between mediums while also priding themselves on paying it forward. He debuted his first sculpture in 2019. He's previously published a zine with Apple and Beats by Dre, plus a retrospective book to commemorate the first anniversary of his design studio, Samuel Ross Associates. This year, he's partnered with Swiss watchmaker Hublot on a sold-out Big Bang Tourbillon.[1] There's also the fourth round of his Black British Artist Grants, which provide Black creatives with funding, and, of course, his menswear label, A-Cold-Wall*, which has opened stores in Seoul and Beijing.[2] If the hours don't seem to be adding up, it's because sleep has taken a back seat. "I need to work on that," he says.

Ross' admission that his "whole life is centered around work" is at odds with the shifting mood of his generation, which has, in the decade or so he's been in the design industry, moved away from exalting the side hustle to embracing the "death of ambition" and "quiet quitting," by way of millennial burnout. But while you might expect someone so highly productive to guard their time fastidiously, no one's clock-watching when we speak on a muggy Thursday afternoon in late summer.

(1) For Hublot, Ross designed a Big Bang Tourbillon watch in orange smooth rubber and titanium honeycomb mesh, with almost all 282 components visible through the dial. His design was issued in a limited edition of 50 and was priced at over $100,000.

(2) A-Cold-Wall* has ambitious plans for expansion in China. Two new stores are scheduled to open, in Shanghai and Shenzhen, by the end of 2022.

Quickly, it becomes clear that what fuels Ross' work ethic is a deep-seated urge to leave his mark on all aspects of culture. His ambition for A-Cold-Wall* and his wider design practice is boundless: "The whole idea has always been to have a multitude of things happening simultaneously. It's not just about fashion—it's about society. It was always about society. It's about how we dress. Eventually, it will be about what we ingest and what we eat, about what we put on our skin. It'll be about how we live and where we live, it'll be about how we engage with print and literature."

Ross' mind moves at warp speed; he theorizes about everything from the decline of feudal systems to the transactional nature of modern-day travel (or "late-capitalist experiences"). At one point, I counter his suggestion that he's not a writer by pointing out the eloquence of his tribute to Abloh for CNN.[3] "I'll read you some poetry that I wrote recently," he says, sifting through the piles on his desk. *You're not a writer, but you write poetry?* "Yeah, I mean . . . you've got to just do things," he laughs.

If Ross is restless, it's in part because he believes that people of color, especially, are living through a unique "pocket of time," even if it's far from perfect. "This is the most free time people of color have ever had in Western society . . . apart from the Moors," he says. "This is a time of autonomy, and I want to leverage that time."

That the window in which to make his mark is narrow has no doubt been brought into sharp relief by the loss of his mentor, "V."Abloh's sudden passing unleashed a seismic outpouring of grief from his legions of friends in fashion, media and culture—but Ross belonged to the innermost circle. He brings up Abloh first, and often, always through a lens of reverence and nostalgia. Speaking about their last interaction is the only point during our conversation at which he slows down. He closes his eyes. "When he died, I cried every day for three weeks," he says. "I haven't cried that much in my adult life."

"If it were up to me, I'd be up a mountain in Guangzhou as a lay monk, just painting."

As streetwear legend goes, the pair began their relationship online. A newly graduated product designer, Ross was brought in to Abloh's fold as an intern, eventually working on Hood by Air, Off-White and Donda.[4] He's the baby of a now-canonized crew that also includes Heron Preston, Fear of God's Jerry Lorenzo and Alyx founder Matthew Williams (who today heads up Givenchy). *Did it feel exciting at the time?* "Yes." *And did it feel like you were changing culture?* "Yes."

(3) In an op-ed written for CNN after Abloh's death in 2021, Ross compared his relationship to the late designer to a Rubik's Cube. "There were many moving parts and we worked across a multitude of disciplines," he wrote.

(4) Donda is Kanye West's creative agency, of which Abloh was named artistic director in 2010. Ross' job, he wrote in his CNN op-ed, was to ensure that Abloh's ideas would take shape as renders, sketches, paintings or prototypes—"done with efficiency and always good taste, refinement and nuance."

(page 53) Ross wears a jacket, sweater and trousers by CECILE TULKENS, a ring by VIRGIL ABLOH and sneakers by A-COLD-WALL*.
(previous) He wears a jacket and trousers by ISSEY MIYAKE HOMME PLISSÉ and sneakers by A-COLD-WALL*.

Ross recalls how he, Abloh and Lorenzo were in Copenhagen just before a game-changing sneaker design was due to drop. "I remember all of us just looking at V's phone and Jerry's phone and passing the phones around and looking at this piece of footwear, knowing what it meant, knowing what it would do." Those who question that impact need only look at the streetwear-infused collections of the oldest, haughtiest fashion houses—or the secondary market prices of the collective's past creations.

Ross' own menswear label, A-Cold-Wall*, launched in 2014, when he was just 25 years old. When we meet, he's dressed in a muted outfit of his own creation that's become a uniform of sorts: paneled ACW* zip-up sweater, matching ACW* sweatpants, and a pair of his ACW* "Hiking Shoe" sneakers. His interest in clothes was always there—though he didn't consider fashion per se until early adulthood. "It was just style—so tracksuits, puffer jackets. It was more about tribe and belonging." His first job, at the age of 12, was as a runner at a streetwear store, and by 15 he was selling counterfeit Nikes. These days, those silhouettes from his youth form the bedrock of his collections—and he's since partnered with Nike on a ready-to-wear collection.

If you were to sum up the Samuel Ross design point of view—what connects a Samuel Ross T-shirt and a Samuel Ross sculpture, for example—you might settle on "Brutalism," a word that was initially used to describe a specific style of architecture and grew to encompass a whole aesthetic. Ross grew up in concrete housing projects in south London and Northampton, and A-Cold-Wall* was initially pitched as a commentary on class in Britain.[5] Ross' famous work ethic isn't just about a creative urge but also, he says, a fear of poverty. His mother is a painter and teacher and his father had studied fine art at Central Saint Martins, but gently steered him toward its more commercially viable cousin, design. He now lives comfortably between a self-renovated house in Northamptonshire and an apartment in the heart of London. "It's not even a thing anymore, but I still have it," he explains.

> "It's very rare that you go from being in the sandbox to talking to the people who tried to design it."

He recognizes the irony of where he ended up—not just as a member of the "0.01 percent," but working out of a landmark 1970s Brutalist building, now deemed an emblem of good taste. "It's very rare that you go from being in the sandbox to talking to the people who tried to design the sandbox. And I got to do that." But to Ross, Brutalism is "the start of art and design" and the first historical movement that he was drawn to.

He moved in to 180 The Strand while it was still a "shell" and has watched it blossom.[6] "I need to talk about the magic of this building, because [Supreme's] Tremaine Emory and Marc Newson were both in here at the same time and we had a beautiful conversation, like, two months ago. That can only happen in 180 The Strand." The expansive space now houses the *Dazed* magazine offices; Soho House's headquarters and one of its members' clubs; HEATED, an LVMH-backed menswear start-up; and the studios of fellow menswear wunderkinds Priya Ahluwalia and Grace Wales Bonner. Not by chance, Ross sits squarely at the nucleus of London's creative scene.

But 10 years into the game, he's also keenly aware that what and who is "cool" is constantly shifting—even more so in the realm of streetwear. Shit-hot brands that draw lines around the block today can be cast aside—even derided—tomorrow. "The benefit of youth

(5) The name A-Cold-Wall* is in itself a commentary on the near-impenetrable nature of certain echelons of British society as well as an attempt by Ross to "articulate the textures of the environment I grew up in," as he put it in an interview with *Dazed*.

(6) In 2009, 180 The Strand was approved for demolition by then-mayor Boris Johnson. However, in 2012 property developer Mark Wadhwa purchased the vast space and transformed it into a creative hub with studios, offices and exhibition rooms. During the eight years it was under construction, the space was used for events such as London Fashion Week and Frieze Art Fair.

Stylist
DAVID NOLAN
Set Designer
SANDY SUFFIELD
Makeup
LUCY GIBSON

(left) Ross wears a jacket by ISSEY MIYAKE HOMME PLISSÉ.
(previous) He wears a sweater by A-COLD-WALL* and his own vintage robe.

> " The benefit of youth is that you organically carry the zeitgeist."

is that you organically carry the zeitgeist. But once that elixir runs out, then there's nothing to hide behind. Is the work good? Is the product good?... We've seen certain trend cycles and perspectives come and go, but the ones that have stayed were never that facile to begin with. They were always going to be there for the long term."

Ross is confident he's building something with legs, though—and that longevity will come down to craft. We go back and forth for some time on the very notion of luxury streetwear, and whether the label even fits. Ultimately, he says, A-Cold-Wall*'s ethos is distinct from the printing on "pre-produced goods" that underpins traditional streetwear. "Let's say we make a new yarn in Portugal, but then we only use Japanese sashiko threading and then we only use mud dye or indigo dye on that jersey, organic jersey." The jacket he's wearing is actually made from merino wool; the sneakers, he tells me, are engineered from an eco-leather composite that reacts to heat and changes color. Early on, he and Abloh, who had a background in engineering and architecture, sought to dub their design philosophy "intelligent streetwear . . . and then people got upset with that." As someone who's so invested in the nitty-gritty of garment-making, Ross seems perfectly poised to find innovative solutions to fashion's sustainability and supply chain crises. I want to know how he feels about being part of an industry that's putting out so much product. "I think about it a lot, and there's obviously loads of guilt associated with volume and scale, because we do have that," he says. "We've started using a lot less nylon, a lot less polyester. . . . Even changing little things like a synthetic thread to a cotton, tens of thousands of reels of plastic are just taken out of the supply chain." However, in Ross' hyperanalytical worldview, it's not so straightforward: The double standards of Western industrialized economies all of a sudden placing sanctions on materials used in "supplier-based villages" in China, for example. Or smaller companies being made to answer for the conglomerates.

Clearly, Ross is equal parts artist and shrewd CEO, and he cares about growing his business. "Scale is really important if we want to see longstanding brands which come from different perspectives, which deserve to be there," he says. Being brought up in a household that was so radical and antiestablishment only made the prospect of making money more alluring, even if he takes issue with the capitalist designation. "So many of my behaviors align [with capitalism], but I don't necessarily agree with that system. I just don't feel

KINFOLK

we can afford any more British Caribbeans to lose at the system." He continues, "I think we need to move forward first in the system, win the system, at least gain more of a voice or a ballot in the system, and then look what our variant of the system might be."

In short, money is the fuel for his manifesto for change. It's the reason he can personally bankroll other Black designers to the tune of over £100,000 through Black British Artist Grants—and the reason why living up a mountain with just a paintbrush and some canvases must remain a pipedream. After all, what is a creative visionary without cash flow?

If he were in pursuit of a hefty paycheck, the most obvious next step might be heading up one of the heritage fashion houses, which are no doubt desperate to mine his talent and cultural cachet. As it happens, five have already come knocking. "Four I wasn't really interested in. One is of interest, but that's all I can say." Still, he has qualms about taking that route. "I didn't do this to get employed. That's kind of what I mean about when we came up in this projection of what the future of fashion should look like. It wasn't for a job. The goal was always to build a new type of company." *But, wait: What about Abloh, who famously took the helm of LV Men?* "I think for Virgil, when he went, that was exciting. It was meritocracy. It was plurality. But Virgil was a Trojan horse. The clothes, that was just to signal. That was just semantics. He was starting to begin with the wider role, like libraries, churches, the work he did in terms of literature, in terms of lecturing.... He was like a Massimo Vignelli."

Abloh's legacy looms large and Ross is his most obvious successor at Louis Vuitton (those supersized shoes remain unfilled). But wherever he ends up, he's not living in his mentor's shadow; instead, he's blazing a trail in his own distinctly recognizable design script. Still, being in Ross' orbit even briefly, I can't help but recall the often-repeated adage that almost everyone who met the infectiously positive Abloh left feeling incredibly motivated. "Yes, but the thing is the actions followed," Ross explains. "You'd have the conversation—and then you'd implement it." What's left unsaid, of course, is that not everyone has the breadth of talent—nor the sheer energy, frankly—to do so with the same success he has.

" I didn't do this to get employed. The goal was always to build a new type of company."

(above) Ross wears a T-shirt by A-COLD-WALL*.

What's behind the latest
drift back to the land?

ESSAY:
HOME SWEET
HOMESTEAD

Words
KATIE CALAUTTI

Scroll through the posts in a homesteading Facebook group on any given day and you are certain to learn a thing or two: the best ways to preserve watermelon; recipes for batch-cooking Spam; how to tell if a cow's leg is broken or just sprained; the difference between toad and snake droppings.

Homesteading—a way of life characterized by subsistence agriculture, preserving food, making clothes and, in some cases, living as if the past 50-plus years never happened—is in a post-pandemic boom. Those who'd been nursing their dreams of living off the land while stuck within their four walls emerged from the pandemic with a cache of knowledge from their vicarious online wanderings.

"We saw hundreds of thousands of new homesteaders come into this lifestyle during 2020 and the beginning of 2021," says Homesteaders of America (HoA) co-founder Amy Fewell, who's currently juggling the organization of this year's HoA conference with a popular podcast, an Instagram account, a YouTube channel and a blog, along with parenting three children and managing her Virginia homestead with her husband. During the pandemic, she launched a "How to Grow Your Own Food" YouTube series which brought in over 10,000 subscribers to the HoA channel in less than 24 hours. Right now, she says, the interest in homesteading is "growing even more because of the food shortages and gas prices." This year's annual conference is sold out, with 5,000 attendees expected.

This is not the first time the US has experienced a homesteading boom. Back-to-the-land movements tend to coincide with moments of scarcity or adversity: the Great Depression, the postwar era, and during the civil rights movement and the Vietnam War. What sets the new generation of homesteaders apart is the striking contrast between the unplugged, solitary lifestyle they have been drawn in by and the very online communities that facilitate it.

Homesteading Facebook groups boast hundreds of thousands of followers, the homesteading subreddit has 2.4 million members and there are 1.9 million posts tagged to it on Instagram.[1] Where those living off the land were once reliant on neighbors in small rural towns for advice, answers about everything from canning fruits and vegetables to butchering livestock to repairing fences to creating medicine for common ailments are now just a click or post away. "I do think that social media has made it a viable option," says Fewell. "People are starting to understand that this is attainable no matter who you are and what you know."

" It's such a wholesome pursuit to want to provide for yourself from your own land. The pandemic just expedited a lot of people's interest."

Homesteading influencers have also found thousands of followers, showcasing their lives through beautifully curated photography and educational videos. Their accounts become a fascinating window into the deeply varying ideological views of those who homestead—from off-the-grid survivalists focused on sustainable living who follow *An American Homestead* to ex-corporate types escaping the rat race who enjoy *Living Traditions Homestead* to those who view it as a way of life that hearkens back to old-fashioned family values and keep up with *The Elliott Homestead* and *Ballerina Farm*.[2]

(1) The private Facebook group Homesteading has over 120,000 members and posts hourly about recipes, land purchases, homeschooling and animal husbandry. A rule of the group: "Anyone can homestead regardless of their political affiliation. This is not a political group please help keep it that way."

(2) Shaye Elliott of *The Elliott Homestead* was described by *The Atlantic* as "the Gwyneth Paltrow of America's growing homesteading movement" in an article that summarized the varying output of homesteaders as somewhere between "*Goop, Little House on the Prairie*, and *Mad Max*."

Those who embrace the way of life as a return to the simpler times of frontier living may be recapturing the traditional family dynamic of the movement's pioneers, but if you till the soils of homesteading history, you'll unearth some rotten roots that few homesteaders acknowledge. The word itself is derived from the Homestead Act of 1862—an initiative to settle American land west of the Mississippi—that offered enterprising farmers parcels of up to 160 acres of government-claimed land for a $10 application fee. But the act left many behind; racism and lack of start-up capital barred most formerly enslaved people from homesteading opportunities. It also displaced Native Americans who'd occupied the land for generations.[3] All told, over the 123 years the act was in place, almost 10% of the United States—270 million acres—was stolen from Native Americans and given to four million homesteaders.[4]

" Farming isn't pretty. It's going to be less beautiful aesthetically than most people show it online."

Though the American West of the past is oft romanticized, *Little House on the Prairie* doesn't tell the whole story. Sixty percent of homesteaders who filed for land failed to develop their plots within the five-year time frame they were given; many had little farming experience or money to invest in materials and tools. Punishing prairie conditions and growing difficulties took their toll. Since those early days of homesteading, modern conveniences and technology have aided in selective adoption of the lifestyle. Tools can be purchased inexpensively at a local store or online,

(3) Renewed interest in homesteading as a way of life has spurred support behind a Native-led Land Back movement to return ancestral lands to Indigenous people; since 2020, there has been an increasing succession of land reclamations.
(4) The act didn't just give the US its largely white rural middle class; if you were to gaze down at the gridlike configurations of farmland from an airplane, you would see its echoes literally etched into the landscape.

seeds can be ordered through catalogs and farm equipment can plow, plant, harvest and process in a fraction of the time it once took.

In September 2020, Kate Brown became the program associate in commercial agriculture with Rutgers Cooperative Extension of Burlington County in New Jersey. "Over my first year I noticed I was getting a lot of calls from new landowners and beginning farmers wondering what to do with their land and whether they wanted to have crops or livestock," she says. In response, she co-founded the Rutgers Homesteading Academy in 2021—a once-monthly series of free webinars where experts instruct on a range of topics, from raising backyard poultry to beekeeping. "It's such a wholesome pursuit to want to be able to provide for yourself from your own land," says Brown, who herself aspires to one day own a small farm. "I think the pandemic just expedited a lot of people's interest in wanting to seek self-sufficiency and happiness on their own terms and do as much as they can to provide for themselves and their family."

As with any movement fueled by online tutorials and images, not every source is reputable. At its most extreme, influencers who engage with homesteading as a sort of extended country vacation from real life are criticized for the commodification of the practice and the erasure of the experiences of those who once turned to homesteading out of necessity. When influencers with supplemental incomes model $20,000 AGA ovens and $500 prairie-inspired dresses, it paints an unrealistic and unsustainable picture of the lifestyle, romanticizing it in similar ways to the pioneer days of the Homestead Act. A simpler time, it turns out, never quite was—and the fallout of its illusion is that it turns away earnest would-be homesteaders.

"You have people that put out this false way of living that might discourage people from living that way because they think it has to be all rainbows and butterflies all the time," Fewell says. "Farming isn't pretty. There's mud and there's poop and there's stuff everywhere. You've got 10 million five-gallon buckets laying around the property and it's just real life, but we live in an Instagram world now.... The beauty of homesteading is that you can do it differently, but I think that people who are interested in homesteading should go into it believing that it's going to be less beautiful aesthetically than most people show it online."

There are many who've proven the lifestyle doesn't require piles of cash or acres of land.[5] Popular homesteaders like Shanna and Francois of *Black Suburban Homestead* began their journey at a local community garden; Kati and Kyle Cearley of *The Urban Ladybug* run a microfarm on just one acre of land; Jordan and Silvan of *Homegrown Hand Gathered* regularly show how they supplement the yield of their suburban homestead with fishing, foraging and plots at community gardens.[6]

The shared belief among all manner of homesteaders appears to be that, in a world filled with chaos and change, we can only count on ourselves. "I do think the one uniting factor would certainly be the food and health care system just not being reliable," says Fewell. "That's what I love about homesteading: It doesn't matter what you believe or what you think or where you come from, whether you're rich or poor or somewhere in between. People are realizing that homesteading is an acceptable way of living.... And it gives them more confidence in their ability to take care of themselves and their family and their community."

(5) Some US states still offer free land to those willing to develop it, although the types of land available have changed. Small towns with dwindling populations use offers of free land to encourage the rebuilding of local communities. Kansas and Nebraska are two states that currently have active programs.

(6) In 2007, controversy erupted after an organization called the Dervaes Institute successfully registered "urban homesteading" and "urban homestead" as trademarks and began insisting that bloggers not use the terms. It took six years of legal action for the decision to be overturned.

AT WORK WITH: Deb Perelman

The little blog that could: An interview with *Smitten Kitchen*'s unflappable founder.

WORDS
ELLIE AUSTIN
PHOTOGRAPHY
CLÉMENT PASCAL
STYLIST
JÈSS MONTERDE
HAIR & MAKEUP
REBECCA ALEXANDER

> "The internet has so many recipes. I only want to publish bangers."

You don't hear many people referring to themselves as bloggers anymore but, as has been the case throughout her career, Deb Perelman is happy to be an exception. "I'm down with still being called a blogger," she says with a smile when we meet at a chic coffee shop in Manhattan's East Village. We're a stone's throw from the apartment that she shares with her husband, Alex, and their two children, Jacob, 13, and Anna, 7. "I guess I'm a cookbook author too."

It's a characteristically self-effacing statement from Perelman, who is one of the most beloved food writers working today. She's frequently mentioned in the same breath as Martha Stewart, Nigella Lawson and Ina Garten and counts Reese Witherspoon and Jennifer Garner as fans.[1] What marks Perelman, 46, out from her peers, however, is her loyalty to *Smitten Kitchen*, the blog that launched her writing career 16 years ago with its steady stream of unfussy, affordable and hearty recipes (examples include roasted yams and chickpeas with yogurt; marbled banana bread; and lentil soup with sausage, chard and garlic).

While many bestselling food writers gradually morph into celebrities, experimenting with splashy TV shows and lucrative product lines, Perelman prefers a more low-key existence. "I've looked at TV stuff," she says. "Maybe there were things that were right but they weren't the right time." Her day-to-day schedule includes testing recipes in her tiny kitchen, uploading them to the blog and then chatting with her legions of devoted readers about those recipes in the comments section. Her tone is warm, witty and informal—like talking to an old friend—with a side serving of self-deprecation and skepticism.

"I was always a picky eater and it segued into cooking," she says. "I'm coming at a lot of recipes from the place of, 'Is pizza *that* good?' Of course pizza is good but is it *always* good? Isn't mac and cheese sometimes a little gooey? I'm a complainer in my head . . . I wanted pizza that was less heavy or chicken soup that was less dry. There are things that always drive me crazy."

The success of the blog ("*Smitten Kitchen*, these days, is not just a food blog; it is *the* food blog," *The New Yorker* wrote in 2017) has led to three cookbooks. The first, *The Smitten Kitchen Cookbook*, was published in 2012 and debuted at number two on *The New York Times* bestseller list. The second followed five years later ("I feel like regular, productive people write books every two years. I don't know anything about that," she says with a laugh). And book number three, *Smitten Kitchen Keepers: New Classics for Your Forever Files*, was released in November 2022. Given that the writing process began in March 2020, the book is unavoidably shaped by the pandemic. "[While writing] I had two kids at home and a husband at home and it was a very different vibe," she explains.

Perelman has always refused to align herself with the domestic goddess narrative. "That's not me," she says matter-of-factly. As such, she's honest about having full-time childcare and, before the pandemic, admits that she never "obsessed over making dinner for the family every night," particularly as restaurant menus are a source of inspiration for her recipes. That changed, however, when stay-at-home orders forced New York to shut down. "All of a sudden we had to cook every single night," she says. "It helped me lop the edges of some of my recipes and hammer home the cooking I wanted to do." What realizations did she come to? "The book is called *Keepers*. It's not a

(left) Perelman wears a a shirt and dress by SILK LAUNDRY.
(right) She wears a coat by STELLA MCCARTNEY.
(previous) She wears a dress by TIBI and shoes by JIL SANDER.

KINFOLK

(right) Perelman wears a dress by KALLMEYER.

promise of forever—what if I find one I like better?—but it's saying, 'I think I could make this pound cake for a long time.'"

Perelman grew up in suburban New Jersey with a father who ate "stir-fries, bagels and mustardy pretzels" and a mother who "loved Julia Child and cooking French and Californian food." The young Deb enjoyed food but wasn't a particularly enthusiastic cook. At 13, she turned vegetarian, largely for ethical and environmental reasons. On moving to New York City in her 20s, Perelman worked as an art therapist at a nursing home. She didn't mind the work, but found herself searching elsewhere for fulfillment.

In 2003, she started a blog called *Smitten* to chronicle various aspects of her life, including the dates she went on. Not long afterward, a kind-sounding man left a comment on one of her posts. They began chatting and eventually met for a drink. Two years later, they were married and the dating blog needed a new purpose. Perelman pivoted to recipes. "I liked to cook and I had very strong opinions about how things should taste and how much work they should be. That segued into something useful for other people, which surprised me."

She applied for writing jobs at well-known food magazines but was rejected. Instead, she took a "mid-level reporting job" at a technology magazine. In 2008, with *Smitten Kitchen* making enough money via ads, Perelman quit her day job to dedicate herself full-time to the blog. Today, it is still her primary focus. "I would really like to have 50 new recipes on the site a year," she says. "The part [of running the blog] that I really like is waking up and cooking whatever I feel like."

Only a handful of food blogs from the early 2000s continue to thrive in today's social media and influencer age. The secret to *Smitten Kitchen*'s longevity lies, in part, in Perelman's willingness to embrace new technologies: *Smitten Kitchen* now has 1.6 million followers on Instagram, as well as a presence on Twitter, Facebook, TikTok and YouTube, but only as a means of funneling readers toward the blog. "I'm almost always directing [web traffic] straight back.... I enjoy seeing what content does better in some places compared to others. Twitter loves a cerebral conversation; Facebook loves a great dinner idea; Instagram loves cake and cookies and sprinkles."

Perelman is candid about the pitfalls of comparing herself online to other food writers. "The hardest thing for me is to keep it from throwing me off. I can think, 'I was going to do something with those ingredients, maybe I should wait.' I don't want it to seem like I'm taking it from somebody." In response, she's developed an unofficial strategy: Credit other cooks and writers as much as possible but don't fret if she and one of her peers are experimenting with similar ingredients at the same time. "You don't have to credit the inventor of lasagna," she deadpans, "but I think it's rude to pretend ideas come out of nowhere. This thing where we all just invented something because we don't want to give credit as if we're afraid it's going to take away from our chance to publish a book? The whole road is so messy and it's allowed a lot of voices to be left out as we take things from other cultures."

Since meeting her husband, Perelman has gradually reintroduced meat into her diet: "I realized I didn't have to buy meat that seemed to be destroying the earth," she says. But she describes herself as a "meat as a side dish kind of person." She is similarly discerning when it comes to fish. "I like oysters, mussels and langoustine tails, but smoked salmon and shrimp fried rice—the things most people start with—they don't do it for me. Oh, I do finally have a shrimp recipe which is now my favorite way to eat shrimp!" she exclaims, darting off on a tangent. "It's chili and garlic butter shrimp—and you cook the shrimp with the shell on because it's like cooking meat with the bone in. It's juicier."

How did she come up with the recipe? "I'll think about how I've cooked shrimp before. I'll look up how this person grills shrimp, or how that person does it. Then I close all the tabs and go with my gut." She grins knowingly. "The internet has so many recipes. I only want to publish bangers."

(1) Of Perelman's second book, *Smitten Kitchen Every Day*, *The New Yorker* wrote in 2017 that "it is poised to take Deb into the realm of her lodestars, the Inas, Marthas, and Nigellas she jokingly writes about imagining herself to be."

In the studio with a sculptor of monuments and mythologies.

WORDS
EMMA SILVERS
PHOTOGRAPHY
KOURTNEY KYUNG SMITH

STUDIO VISIT: Yoko Kubrick

FEATURES

From an industrial park in Silicon Valley, Yoko Kubrick is summoning gods and monsters. When the door of her large, nondescript unit is rolled up, a world of beauty reveals itself: The sculptor makes monumental bronze and marble works—nine-foot-tall sculptures full of quiet surprises and subtle, erotic references to plant life and the ocean.

Born to a Japanese mother and Czechoslovakian father in the US territory of Guam, Kubrick grew up moving between Guam, Hawaii and San Francisco, spending summers with her grandparents in what is now Czechia. Sitting in a workspace overflowing with carving tools, small plaster studies and stacks of art and philosophy books, she credits her early inspiration to Hawaii: "There's Indigenous sculpture everywhere, and the way the teachers in school talked about the mythology behind them was to tell these stories like they were *real*," she says.

Storytelling is now central to Kubrick's practice, with ideas for her work sparked sometimes by myths about ancient gods and goddesses and, at other times, soap operas. "Across cultures, when you boil it down, there are these common stories," she says. "If you look at Will Smith and what happened with that slap? That's what a lot of Greek mythology reads like: gossipy dramas between people. Rage, jealousy, revenge, not being able to control our emotions. They're stories about human nature."

EMMA SILVERS: From 2016 to 2019, you lived in Tuscany, where you learned to carve marble from third- and fourth-generation sculptors. What role does tradition play in your work?

YOKO KUBRICK: I love traditional materials. I lived in Pietrasanta, which has

(above)
A fragment of a mushroom coral skeleton (center) and a handmade rasp, the coarse file used by marble carvers.

the highest population per capita of sculptors anywhere in the world. Some foundries go back multiple generations and so much of the sacred sculpture around the world is from there. These sculptors were so specialized—when they made angels, they would have one guy who did faces, one guy who did wings and feathers and another guy who just did the flowers. I actually met one of the last flower carvers in Pietrasanta. They stopped training them that way, because it doesn't make sense economically; they all became generalists. I think it's kind of sad that's being lost. This guy, Franco Lombardi, you give him an air hammer and a chisel and he could carve roses blindfolded.

ES: Did that experience affect how you think about American art?

YK: Well, while I was doing my apprenticeship I also met sculptors from all over the world—Venezuela, Japan, the Czech Republic. I was the only American. We would sit and have these dinners and get into debates and it would often turn into an attack on Americans, like, "You guys don't have any art history." I would sit there and listen to this, until something dawned on me one day and I started pushing back: *Maybe it's a good thing we aren't so tied to our history and culture the way Italians are.* Most contemporary Italian artists are figurative; they're very rooted in their tradition, and even when they do try to break away from it, it's very difficult for them. I think that's why a lot of the early abstract expressionists were children of immigrants—like Mark Rothko. They're breaking away and starting new. Similar to how, in the Bay Area, because we're not married to so much

(left) Kubrick trained in Pietrasanta, a small Tuscan town known for its 50-plus marble workshops. Sculptors including Henry Moore, Isamu Noguchi, Joan Miró and Fernando Botero also spent time perfecting their craft there.

(right) The stone a sculptor chooses to work with will affect the look and feel of the final piece. The sculpture in the foreground is carved from statuary marble, which has a smooth aspect, whereas the one behind it is carved in titanium travertine, which retains a matte finish.
(below) Kubrick often takes inspiration from classical mythology when naming her sculptures. *Panta Rhei* translates as "everything flows"—an aphorism of Heraclitus that expresses the fact that the universe is in a state of constant flux.

tradition, somebody can say, "I'm going to start an app where I rent out my air mattress, okay?" And we're like, "Great!"

ES: You have a master's degree in psychology and art therapy, and previously worked at a psychiatric facility as an art therapist. Does that background inform your work?

YK: It has to do with how I fell in love with abstract art. I think the gap between reality and that abstract shape opens your mind—almost like a Rorschach, where you can project your own interpretation onto it. Carl Jung said that we have this collective unconscious, so certain shapes and forms are preprogrammed in our minds to elicit a response. If you show even a very young child the shape of a spider, there's a fear or revulsion response, right? I think about why humans love flowers so much. And if you think about it, a flower is the sex organ of a plant. In a lot of my sculptures, I might take some shape out of a plant, some shape out of a woman, and just try to touch that pleasure or curiosity point in the mind.

ES: You're currently creating pieces for an exhibition in the gardens at Filoli [a nearby historic estate-turned-museum] based on Ovid's *Metamorphoses*. What drew you to that work?

YK: If you look at Renaissance art, even Shakespeare, so much of it comes out of this one epic book of poetry and fables. But the thing that I found fascinating was scholars think it was the first time in written literature that the woman was portrayed as the protagonist. So these pieces will be interpretations of female heroines. And part of my proposal was that, in the gardens, with this large-scale work, the art becomes a place of refuge and the audience really becomes part of those stories.

ES: Some of your work is installed in public places, like the University of San Francisco campus. How do you think about making public art versus sculptures that wind up in private collections?

YK: If I could get enough commissions, I would actually love to only do public art. Having studied art therapy, I think all hospitals should have therapeutic gardens. And I just think about art in terms of urban design, town centers, piazzas. Growing up in San Francisco's Japantown, Ruth Asawa's sculptures were everywhere. I used to play in that fountain at Peace Plaza when I was a kid. I remember sitting out there with my dad when he was talking to his friends—just that open space with the artwork as the focal point. Art becomes a marker where memories are made. I also think, in terms of accessibility—especially when so much of the world's wealth is concentrated in Silicon Valley—why *don't* we have more public art? People here can afford it. I've thought about this a lot. In Italy, Florence is a center of so much opera, sculpture, architecture. None of that would have happened without the Medici family, who were incredibly important patrons of Renaissance art.[1] I think the way to go about it with the Mark Zuckerberg types is to make it a social responsibility to support visual art, music—comedy, even. To get them to realize that they have, potentially, a very important historic role, to be the patrons of the next generation of culture and art. If all we have is Google, what do we really have?

(1) The Medici family, owners of the most powerful bank in 15th-century Europe, is seen as responsible for ushering in the Renaissance in Florence because they commissioned the city's artists and built a host of buildings through which to disseminate culture. None of this was altruistic; the family saw the arts as a means of gaining popularity and cementing its rule.

76 FEATURES

Words
DAPHNÉE DENIS
Photography
LUC BRAQUET

Charles de Vilmorin

Wild. Weird. Wearable: Meet the couture protégé challenging the norms of French fashion.

"Perhaps we could say I made these?" Charles de Vilmorin says cheekily, as he turns toward the Viktor & Rolf fall 2022 couture collection hanging on a rack at his publicist's Parisian showroom. We've been perusing a selection of Vilmorin's own fall 2022 looks: colorful, theatrical ensembles, some of which he hand-painted with eerie alien faces, mysterious flowers and even pints of beer foaming over a white shirt—a personal favorite of his. The flashy colors of his pieces contrast with the matte brown and dark blue palette of Viktor & Rolf's garments, yet it's easy to see how the Dutch fashion duo may have inspired the 26-year-old designer. They share a penchant for exaggerated silhouettes and dreamlike aesthetics as well as a clear sense of drama and poetry. When his PR manager remarks that he has rarely mentioned the fashion house as an influence before, Vilmorin concurs. "But I'm a fanatic; they once made an all-white collection as a tribute to Picasso, it was *sublimissime*," he enthuses, granting the cubist-inspired spring-summer 2016 collection a quintessentially French superlative.

Vilmorin's candor when it comes to the work of others is disarming considering his own spectacular debut in the world of fashion and the support he has received from some of the most respected names in the industry. He was fresh out of fashion school—he attended the prestigious École de la Chambre Syndicale de la Couture Parisienne—and only 23 when he launched his eponymous label on Instagram, as France's COVID-19 lockdown was drawing to a close.[1] Right away, the celebrated pop-art designer Jean-Charles de Castelbajac took to his own social media channels to sing his praises: "I have seen him grow confident day after day, needle after needle," Castelbajac wrote in an Instagram post. "He draws his dreams.... His silhouettes transform his muses into psychedelic conquerors, I recognize my 20-year-old self in his boldness. His panache is colorful, and his future filled with passion."

"Niki de Saint Phalle on acid," is how *Vogue* described Vilmorin's first designs, some of which were indeed an homage to the pioneering feminist artist's *Nana* sculptures of curvaceous, liberated women. Just months after his brand's launch, American rapper Tierra Whack appeared in an Apple ad wearing one of his quilted patchwork puffer jackets. In January 2021, another one of Vilmorin's fashion godfathers, Jean Paul Gaultier, sponsored his first guest appearance in the Paris Haute Couture calendar. Weeks later, he was appointed creative director of one of France's oldest fashion houses, Rochas. It all happened in less than a year.

(1) The school, which merged with Institut Français de la Mode in 2019 to create a "super school" to rival London's Central Saint Martins, is closely associated with Paris' Fédération de la Haute Couture et de la Mode, the organization in charge of deciding what gets to be classified as couture. Vilmorin joins a list of notable alumni that includes Issey Miyake, Valentino Garavani and Yves Saint Laurent.

Sitting in the office of PR maven Lucien Pagès, who represents anyone who is anyone in Paris fashion, Vilmorin himself seems somewhat perplexed at how things turned out. Procrastination may have helped. Back in 2019, he had been working on personal projects with friends instead of looking for the internship he needed in order to graduate. By the time he contacted fashion houses, they were no longer hiring, he says, so his parents told him to find a job or come home to Compiègne, where they lived at the time. Then, a collector offered to buy some of the garments he had designed as a student, that were being promoted online. "It was totally unexpected," says Vilmorin. "It meant I could fund my business, I could pay pattern makers." He moved back in with his parents so he could invest the money in his first collection. Soon after, the pandemic hit.

"When I'm sewing, I'm not that fussed about the finishes. It's about pouring my soul into it."

Though there has been a lot of talk about Vilmorin's distant relationship to early 20th-century poet, novelist and socialite Louise de Vilmorin, his family had no previous ties to the fashion industry. As an artistically driven child, he planned on becoming a theater director. It was the drama of runway shows, first experienced as a teen, that suggested a different path. He credits a spring 2011 Dior show by John Galliano with convincing him to draw a full collection for the first time. "It was a couture show inspired by an illustrator I used to love, René Gruau. It was all red and black, and Karlie Kloss opened it; her walk was insane," Vilmorin recalls. "I was really moved, and I decided that that's what I wanted to do." He remembers having to hustle, while still in high school, to get an internship at Lanvin, then helmed by Alber Elbaz.

FEATURES

For an outsider, the world of haute couture can seem impenetrable.[2] The designation itself, which awkwardly translates as "high dressmaking" in English, can only be legally used by a handful of Paris-based fashion houses, and even fewer foreign members. To be eligible, designers must create custom-made garments for private clients in an atelier employing at least 20 artisans, do at least one fitting, include handwork, and present two collections of no less than 25 original looks each in January and July. They may be invited as guests, like Vilmorin was in 2021, but in order to be accepted into this very select club as a full-time member, a fashion house must have appeared as a "guest member" in the official couture calendar for four years in a row, and be sponsored by another *maison de couture*. Admittedly, Vilmorin is not there yet, but he was one of the few young designers to be included in the couture calendar for three seasons in a row before going off-schedule in July 2022—a move that allowed him more creative freedom, he told press at the time.

For Vilmorin, couture is, first and foremost, about creating something unique through handwork, no matter the technique. He doesn't use a tape measure—he has a keen eye for proportions—and cuts his fabric with a pair of kitchen scissors. "When I was added as a guest on the couture calendar, it was a lot of pressure because I didn't have that haute couture savoir faire," he says. "I love to create volume and give life to garments, but when I'm sewing, I'm not that fussed about the finishes. So I decided to paint everything by hand: It was about pouring my soul into it, using my hands for hours." At the publicist's showroom, an unfinished hand-painted gown, which Vilmorin describes as "crafty," hangs near an impeccably executed pink and red dress with an oversized collar reminiscent of *Alice in Wonderland*'s Queen of Hearts. The contrast between DIY and perfection is what makes "crafty" beautiful, Vilmorin says with a pinch of irony. So far, his peers seem open to this radically different interpretation of couture.

> " With black, you cannot hide behind patterns. Color is a little like camouflage."

Often compared to a young Yves Saint Laurent for his looks—he is partial to a black turtleneck and wears retro metal-rim glasses—Vilmorin feels aesthetically closer to the dark romanticism of Alexander McQueen, vowing to bring back the late designer's "hyper extreme" approach and emotional intensity.[3] His muses are gothic characters and aliens, which he says he likes because they are genderless and stateless, meaning they can resonate with anyone.

While some interpret his signature use of color as joyful, Vilmorin argues that some of his flashier designs, like the quilted jacket from the Apple commercial, actually came from a somber state of mind: "There was something a little trashy about it, as if I were vomiting colors," he explains. Creating an all-black fall-winter 2021 collection, on the other hand, came from a place of confidence: "With black, you cannot lie, you cannot hide behind patterns. Color, for me, is a little like camouflage, I think." He hesitates and looks at his publicist. Could he be contradicting himself? Has he ever said this before? It doesn't matter, he decides after a short pause. "With time," he muses, "I'm gaining perspective."

(2) For wealthy patrons, the appeal of couture lies in its exclusivity: You need to be in the know and well-connected to even be aware of what is for sale. For the rest of the fashion industry, couture remains relevant as a source of inspiration and to see what designers can do when money is no object. Trends are then adapted and scaled for commercial lines.

(3) Vilmorin told *Purple* magazine in 2020 that he likes it when clothes are "disturbing" and that he relates to McQueen's well-known statement, "I want people to be afraid of the women I dress."

The upside of
downtime on a slow
Sunday afternoon.

89 HOME FREE

Photography
ROMAIN LAPRADE
Styling
GIULIA QUERENGHI

(below) Beatriz wears a sweater by TORY BURCH.
(previous) She wears a sweater by MOLLI, trousers by MAX MARA and shoes by PAUL SMITH.

(below) Rishi wears a cardigan and sweater by AURALEE, trousers by DRIES VAN NOTEN and shoes by PRADA. Beatriz wears a bra and shirt by
 HENRIETTE H, a skirt by AURALEE, and shoes by NOMASEI.
(right) Beatriz wears a dress by SPORTMAX and shoes by PAUL SMITH.

Photo Assistant: Paolo Fava

KINFOLK

(below) Rishi wears an outfit by LORO PIANA.
(left) Beatriz wears a turtleneck by LORO PIANA and shorts by TRESSÈ.
(overleaf) Rishi wears a sweater by GIULIVA HERITAGE and trousers by AURALEE.

Hair & Makeup
HELENA HENRION
Models
BEATRIZ RONDA
RISHI ROBIN
Location
ANTICÀMERA LOCATION AGENCY

III

98 — 176

INTERIORS
Around the world through 10 interiors.

98	Bush Modernism	140	California Cool
108	Gothic Revival	148	Seaside Studios
118	Cairo Calm	156	Rural Splendor
124	Cubist Cocoon	164	Faded Grandeur
132	Medieval Modern	170	Heritage Craft

(SEAN FENNESSY & JESSICA LILLICO, AUSTRALIA)

BUSH MODERNISM:
Rebuilding the legacy of desert architect Alistair Knox.

WORDS Rosalind Jana PHOTOS Sean Fennessy STYLING Jessica Lillico

KINFOLK

"People didn't see the modernist elements of it. It felt quite heavy."

When photographer Sean Fennessy and art director and stylist Jessica Lillico began looking for a house, they knew it might take time. The Australian couple wanted to move on from their small Melbourne apartment and find a proper home that would hold a family of four. After many months and a lot of research they alighted on the work of Alistair Knox. The designer of more than a thousand homes between the 1940s and the 1980s, Knox developed an organic, angular style now dubbed "bush modernism." Fennessy and Lillico's home, known as the Fisher House, is 15 miles from Melbourne in the suburb of Warrandyte and has been sensitively restored, retaining the building's earthy hues and mid-century spirit.

ROSALIND JANA: Tell me more about Alistair Knox. Why did his bush modernism appeal to you?

SEAN FENNESSY: When he started building houses out here it was [still] bush, back in the late 1950s and early '60s. He was building with local materials: mud bricks, timber, recycled things. Knox was quite ahead of his time. A lot of the houses have been renovated [since] because the characteristics of his work are this dark timber, lots of textured brickwork.... In the '80s and '90s or even more recently, that wasn't a particularly popular aesthetic. People would just whitewash it or rip out the timber kitchens. We weren't interested in the houses that had happened to because the idea of stripping that back or reinstating everything, I don't even know if you could practically do that. Anyway, we found this place that had been basically untouched since it was built in 1969.

RJ: That's funny—and also sad to hear—given the present popularity of his work.

SF: Visually, I think, people didn't see the modernist elements of it. They just saw the timbers and bricks, and it felt quite heavy. But there are these modernist and mid-century characteristics: straight lines, raked ceilings, a general simplicity in the shape of these buildings and their orientation on the land. That is fundamentally modernist. It just doesn't necessarily look like Palm Springs.

RJ: This seems like a house designed to be in tune with the outdoor world surrounding it.

SF: Absolutely. As well as being interested in the architecture, the idea of having this space was really a draw after living in an apartment in the city. The landscape design was always an element of Knox's approach to a new building, which makes sense when you see the big windows. The outside is right there, so [why not] extend the experience of the house into the garden?

RJ: Do you feel much more attentive to things like the changing of the seasons?

SF: You do because the front is all glass. And we don't have any curtains. Especially in the winter, it's dark when you get up but then you're facing east so you see the sun coming.

RJ: What other examples of bush modernism do you admire?

SF: There's a house that forms part of a museum not far from here, the Heide Museum of Modern Art. It was designed by some Melbourne architects—David McGlashan and Neil Everist—for the owners to eventually turn into a [habitable] gallery. It's called Heide II. That was very inspiring, especially the interiors.

(left) The family's dining room features a painting by Zoe Grey, dining chairs by Henning Kjærnulf, a custom dining table by Fomu and a floor lamp by MakeBelieve.

(right) An artwork by Aboriginal artist Ita Tipungwuti, which Fennessy and Lillico purchased in the Tiwi Islands, hangs in the kitchen.

(right)
A Double Bubble pendant light,
designed by BARBER OSGERBY for OZEKI & CO LTD,
hangs over the bed in the primary suite.

(CASA VICENS, SPAIN)

GOTHIC REVIVAL:
The eclectic ornamentation of Gaudí's first commission.

WORDS
Agnish Ray
PHOTOS
Marina Denisova

When Antoni Gaudí graduated from university, the school's director said that he was either a genius or a madman. It's uncertain which of the two appealed to Manel Vicens, the stockbroker who commissioned the recently qualified—and somewhat unpredictable—architect to build his summer home in 1883. The result was Casa Vicens, a flamboyant burst of color and style in the elegant village of Gracia (now a district of Barcelona) and the first of Gaudí's many masterpieces whose collective eccentricity would become the defining symbol of the Catalan capital.

The hand-painted tiles that adorn the home epitomize the architect's vivid imagination: Green, white and turquoise ceramics, many painted with marigolds, populate the facade; the naturalist ceiling tiles in the dining room are made of *cartón piedra* (similar to papier-mâché), while sgraffito ivy leaves creep up the walls. Roses dance across the blue and ocher checked ceramics on the walls of the smoking room.

Before Casa Vicens opened as a museum in 2017, restoration of these vibrant ceramics was an essential task; many original pieces were found to be damaged beyond repair. Local ceramicist Manel Diestre made replicas using the same transfer printing technique as Gaudí's original artisans, painting over wax paper stencils called *trepas* in Catalan.

Not yet displaying the awe-inspiring scale and sublime emotion of Gothic architecture that appeared in his later works, Gaudí's first commission represented the whimsical experimentation of a young, intrepid visionary playing with different styles. "He had a lot of ideas in his head," says Casa Vicens director Emili Masferrer, "often very mixed, even contradictory." The vaults in the basement, for example, are typical of a traditional Catalan farmhouse, but the blue *muqarna* vaulting in the smoking room's ceiling resembles an Iranian mosque.

The arched windows and the minarets on the roof also signal Gaudí's romantic gaze toward Islamic architecture, as does his use of a water fountain for cool respite during Barcelona's sultry summers. Meanwhile, the wooden lattices covering the windows mimic Japanese *shitomi* shutters. Gaudí never visited the Middle East or Asia but he devoured texts and images related to their design traditions; the explosive confluence of styles found at Casa Vicens captures the fever of Orientalism in 19th-century Europe —a dreamy, ornamental vision of the distant yet alluring aesthetic cultures of "the East."

From the floral motifs in the tiles to the leaf patterns of the cast-iron railings, organic shapes and fertile imagery were the architect's homage to the gardens he found on the original plot. "In Casa Vicens, nature becomes architecture," explains Masferrer. "Gaudí eliminates the limit between interior and exterior, so that even inside the house it feels like a garden." Gaudí's representation of nature is devotional: In the flowers, plants and trees surrounding Casa Vicens, he saw the vision of the Almighty—one for the architect to imitate faithfully in order to rejoice in God's glory.

(left) One of the more unusual features of Catalan modernisme architecture is the use of cartón piedra. Gaudí used the material to make lightweight moldings in order to decorate the ceilings of Casa Vicens with natural motifs.

(right) Before its reopening as a museum in 2017, Casa Vicens had been a private home for 130 years. Several of its original features were destroyed or covered over during this time, and many of the tiles seen today are replicas.

(left) Gaudí's marigold-patterned tiles, inspired by flowers he found growing on the site, are perhaps the most celebrated details of Casa Vicens. Today, a single vintage tile from this commission can sell for around $1,000.

(below) Casa Vicens was intended as a summer house, and water played a big role in Gaudí's design. A replica of the largest water feature—a waterfall in the garden that was demolished in 1946—is exhibited at Museu Agbar de les Aigües on the outskirts of Barcelona.

(SHAHIRA MEHREZ, EGYPT)

CAIRO CALM:
The Hassan Fathy masterpiece that a costume collector calls home.

WORDS Rowan El Shimi PHOTOS Ämr Ezzeldinn

The Cairo skyline is a maze of satellite dishes, rebar, minarets and pigeon lofts. Many of its rooftops hold informal housing, often for underprivileged immigrants from the countryside.

One rooftop stands out: the apartment of 78-year-old Shahira Mehrez, which tops a six-story building in the upmarket neighborhood of al-Dokki on the west bank of the Nile. Built in 1971 by renowned Egyptian architect Hassan Fathy, who pioneered the use of ecological materials and traditional building design in contemporary settings, the penthouse has been Mehrez's home for the past 52 years.

Mehrez is a designer, scholar and collector of traditional Egyptian costumes. With her French education and roots as a Muslim in Egypt, Mehrez always felt hinged between two worlds. "For the Egyptians, I was French and for the French, I was Egyptian. I was nowhere," she explains, relaxing in the open courtyard of her apartment. After hearing about Fathy and his work in the mid-1960s, she sought him out and started visiting his home and studio in 1967. Meeting Fathy completely changed her perspective on her duality: "He told me I was very lucky that I had the opportunity to belong to two cultures and could take from each what suited me best," she says.

From there came the project for the apartment, which was added to a building already owned by Mehrez's family, and completed in 1971. Fathy brought his signature approach of environmentally conscious building and traditional motifs.

Upon entering the rooftop via the elevator, one is met with a *magaz*, a wooden structure that protects the privacy of the owner, followed by a hallway that leads to an open-air courtyard with built-in marble couches, marble floors and a traditional fountain in its center. Fathy designed the space to maximize airflow to counter the hot summer climate, and this is where Mehrez spends most of her time, enjoying the breeze.

Mehrez told Fathy that she wanted her interior space to be a "small, big room." It's made up of two levels: On the lower level, there's a workspace and hosting area and on the upper level, closed off behind colorful sequined curtains, is her bedroom—all under a tall wooden traditional structure with windows on every side. There's also a marble bathroom with a vanity, built-in couch and traditional tub on the upper level.

"When I have people over, I can use the whole space with people outside in the courtyard, in the lower space of my bedroom or even in the bathroom, where I would often have ice in the tub for drinks and people could sit and enjoy their beverages on the marble sofa," she says. "Now that I'm older, I have more high tables to eat and to write at," she continues, counting six workstations in the three rooms where she sits and writes her book when she's not working on one of her sofas outside.

Mehrez explains that Fathy did not consider himself an architect for the rich. "He would say, 'You're not my client; my clients are the millions due for premature death because of bad habitat. I build for the poor,'" she recalls. Fathy's flagship project was New Gourna, a village on the west bank of the Nile built between 1945 and 1948 to house those displaced by the booming tourist trade at the famous temples on the east bank. Despite Fathy's vision, his use of sustainable materials and his involvement of the community in the design process, the project ultimately failed; only a fraction of the local population moved there. Fathy detailed the story of New Gourna in his book *Architecture for the Poor*.

In a way, Mehrez and Fathy have both lived by the belief that Egypt lost its way in the 20th century when it dropped its traditions for a more Western approach. Mehrez is currently writing *Costumes of Egypt: The Lost Legacies*, a four-volume book documenting Egypt's costume tradition, and a culmination of her life's work. "[Fathy's] work was much more important, as you can't avoid architecture, as he would say," she explains. "But in a way, we both failed. He was trying to preserve tradition that was more environmentally conscientious and build with ecological materials and I was trying to push Egyptian society to at least preserve their clothing and traditional costumes by wearing them. I failed . . . I'm the only one wearing them!"

(right) Mehrez has spent a lifetime archiving the regionally specific dress of Egyptian women. Her 500-plus costumes aren't stored in her penthouse, but it is full of antique textiles and books on Egyptian history.
(below) The apartment makes the most of its positioning on the top floor of the building with an open-air courtyard and a skylight in the bathroom.

(left) A traditional *majlis* (the Arabic word for sitting room) designed by Fathy, featuring long, low sofas on three sides.

INTERIORS

(REVERSIBLE DESTINY LOFTS, JAPAN)

CUBIST COCOON:
Nine lofts designed to challenge your senses.

WORDS
Selena Takigawa Hoy
PHOTOS
Ben Richards

Walking into the Reversible Destiny Lofts in suburban Mitaka, Tokyo, is a disorienting experience. Next door to a McDonald's and some uniform beige apartment buildings, the complex appears as a sudden burst of colors and shapes, improbably stacked three stories high. It looks like a pile of children's blocks writ large. Inside each loft, where you must proceed sock-footed, the floor is pitched, bumpy and undulating. A sunken kitchen stands at the center of the circular space, a hammock hanging from the ceiling next to it. Small rooms—straight out of *Dr. Seuss*—are attached at jaunty angles orbiting the main room. Walking around can make you dizzy at first.

Discombobulation is the whole point. The lofts were created in 2005 by architect couple Shusaku Arakawa and Madeline Gins, and every element—the improbable shapes, angles, textures and colors—is designed to keep you off-balance, to propel you out of your comfort zone. Arakawa and Gins had been partners in art and life for more than 40 years by the time they built these nine lofts. The full name of the complex is Reversible Destiny Lofts—Mitaka (In Memory of Helen Keller).

"Helen Keller was an extraordinary person who used a number of senses other than her eyes and ears," explains Momoyo Homma, director of Arakawa and Gins' Tokyo office and the Reversible Destiny Foundation. "According to Arakawa, human beings have hundreds or thousands of senses," says Homma, but most of them lie dormant. We use them when we are babies, or when we are forced to under exceptional circumstances, as the deaf-blind Keller did so famously. "So this apartment is like a model for us to learn how we can expand our body perception and senses."

"It's a model for how we can expand our body perception."

The lofts come with "directions for use" by Arakawa and Gins that include whimsical ways to experience the space. "But the way to live in this space is up to each resident, and everybody has a different body," says Homma. "That's why it's a work in progress—so that you can continue adding your own directions."

Hooks on the ceiling encourage use of the vertical space, while the spherical room feels cozy and womblike. Right angles are scarce, so your relationship to rooms, tasks and other people may differ from usual. "For example, Mariko, my friend, is very tall, and Shinichi-kun, my other friend, is short, but when they come here, Mariko could be very short and Shinichi-kun could be very tall," explains Homma. People can get locked into self-perceptions; the Reversible Destiny Lofts give them a chance to shift the idea of themselves.

Most of the lofts are occupied by long-term tenants, while two are available for short-term stays. "Arakawa and Madeline really believed that architecture has much more potential to change your life," says Homma. When you come here, you'll be topsy-turvy. Embrace it, recalibrate and put yourself back together in what is, with any luck, a new and improved formation.

(overleaf) The uneven floors at the lofts were designed to ensure inhabitants can never get comfortable, meaning that their bodies remain as engaged as they would be were they standing on a balance board at the gym.

"The way to live in this space
is up to each resident."

(above) The floor of the living room is made from a mixture of cement and hardened soil and was designed to be an undulation of bumps, some the size of tennis balls, others as large as grapefruits. Only the floors of the bedrooms are flat.

(BARBARA CASASOLA, ITALY)

MEDIEVAL MODERN: A designer's peaceful home in a Florentine palazzo.

WORDS Laura Rysman PHOTOS Cecilie Jegsen

When I arrive at Palazzo Guicciardini in Florence, tourists are pressed against the iron gates, jostling for a view of this medieval marvel. They aim their phone cameras toward the palazzo's serene garden, with its meticulous topiary and blooming rose bushes bordered by the Medici's famous Vasari Corridor.

For Barbara Casasola, a fashion designer who has cultivated a passionate following for her essentialist clothing line, this is not a landmark—it's home. I squeeze past the crowd of tourists and head upstairs, where she greets me at the door and leads me into her living room. It neighbors the apartment of the Guicciardini descendants; the family has owned this palazzo for hundreds of years.

In the 13th century, these quarters housed the famously humble and beatific St. Philip Benizi, who hid himself away rather than take on the role of pope. "I think you can feel that presence—there's still a real sense of peace here," says Casasola. Many of the apartment's historical details have remained intact, with a trompe l'oeil mural of flowered coffers on the vaulted ceiling, as well as doors and shutters painted with florid heraldry. This is largely down to good luck: Palazzo Guicciardini was one of only a few buildings on this street to survive the mine explosions set by retreating Nazis.

Despite its medieval roots, the space feels airy and modern, with mid-century furniture and a pair of jungle-sized potted plants, plus several racks of Casasola's designs; the palazzo doubles as her showroom. In the foyer, amid framed shots by the 1990s-era Maison Margiela photographer Mark Borthwick, a good friend, Casasola shows me her new bucket bag design. It's the brand's first-ever purse, crafted at the same Tuscan workshop that Bottega Veneta employs. The bag is exacting and clean-lined, but free of rigidity—the essence of her simple style. She then pulls out a brown sweater-dress in silk cashmere that features a knit tunic tied at the waist. It's a bit "Franciscan monk," she jokes, but streamlined into functional, contemporary layers that eliminate the need for a coat. Rejecting the quick-change cycle of the fashion calendar, the collection is built of high-quality wardrobe heroes in natural tones, like the wheat-hued knit tank dress Casasola wears the day we meet.

"As a designer, you have a necessity to make stuff, but what you make has to matter," she says. Everything must be "more than utilitarian: It has to have soul." Next to Marzio Cecchi's 1970s curved Banana Leaf wicker chair, a honey-colored cotton macramé dress hangs in the window, the fruit of 40 hours of hand-knotting by a craftswoman in Puglia.

Casasola wears no makeup or nail polish and looks elegant and arresting; a designer's line drawing come to life. "The goal is to change the mentality. I want to be a solution for women," she says, citing her many "converted" friends who have simplified their wardrobes, like the artist Lola Schnabel, whose artichoke ceramics rest on the table. The Casasola client rejects glitz and trends in favor of enduring style and low-impact consumption. "We are the Italian answer to this change. We're small. We're independent. But we have the best quality, the best supply chain and real values," she explains.

In 2019, the Brazilian-born designer relocated from London to Florence, the city where she first began her career at Roberto

Cavalli in the late 2000s, a few years before founding her own brand in 2012. "We're in the heart of craftsmanship here in Florence, so I can create more, and I can have a humane, one-on-one relationship with the artisans, but I also wanted to reduce my carbon footprint and stop shipping samples back and forth," she says.

"And here," she confides, leaning back on a white linen couch she designed herself, "I have the most chill life."

Casasola points to another white seat, this one like an amusement park's teacup ride: the 1966 Cesare Leonardi–designed semisphere of fiberglass on a swivel base. It is her morning meditation spot, she says, and one of many pieces on long-term loan from the Simone Begani gallery in Florence. Having her showroom at home, in this photogenic palazzo, allows Casasola to work in proximity to her husband and toddler and to furnish the space in collaboration with galleries. From her first venture with the Brazilian design specialists at Etel gallery in Milan, she retained a 1951 Lina Bo Bardi chair tipped with a brass sphere. From Begani, she currently has a slew of works, including an Andrea Branzi wood sculpture, a pair of gracefully squat "925" leather armchairs by Afra and Tobia Scarpa, and a monumental white coffee table on plexiglass legs by Roberto Monsani. On the coffee table, a giant tome on Jung sits beside our half-eaten baked grape rolls, a delicacy in Florence during the harvest season.

The curated showroom seems almost too perfect for a real living space, or at least for one with a small child around, but Casasola has given over the kitchen to her son, who's filled its walls with his exuberant finger paintings. "I wanted to practice attachment parenting," she says, "and the only way I could do that and keep working was to have my work at home."

Her son ambles across the room and accepts a bit of sweet roll before crawling onto Casasola's lap for a hug. It is indeed a chill life, but it's this tranquility, expressed in her clothes, that imbues her designs with their galvanizing power.

(left) Casasola is pictured in a 1966 fiberglass chair by Cesare Leonardi, who is perhaps best known as a landscape architect and the author of the influential 1983 book *The Architecture of Trees*.

(previous) Much of the furniture at Casasola's studio is on loan from the Simone Begani Fine Arts Gallery, a boutique gallery located in Florence between the neighborhood of San Frediano and Piazza Santo Spirito.

WORDS George Upton PHOTOS Justin Chung

(MARY BLODGETT & CARLTON CALVIN, USA)

CALIFORNIA COOL:
A mid-century post-and-beam house that blends with the nature around it.

Mary Blodgett and her husband, Carlton Calvin, came close to demolishing their modernist home in a leafy suburb of Los Angeles after buying the land in the mid-2000s. The single-story house in San Marino had been designed in 1954 by Calvin Straub, a leading proponent of Californian modernism, but it was falling into disrepair. The couple had even gone as far as to commission plans for an ambitious new home for the site before they eventually decided to remodel it and build a series of pavilions on the grounds. "The main house has a kind of structural rhythm," says Alice Fung, a founding principal of Los Angeles–based Fung + Blatt Architects, whom Blodgett and Calvin enlisted to lead the sensitive restoration and redevelopment of the estate. "We came to understand that rhythm and improvised around it."

Fung's practice had initially been contacted in 2009 to convert an "obsolete pergola" in the garden into a ceramics studio for Blodgett, the existing garage into a bedroom suite and to build a library for Calvin. Their approach was experimental: The only elements that remain of the original pergola are the roof beams and eight columns—the new walls are an infill of wood shelving and glass that looks a vitrine when viewed from outside; one wall cuts dramatically across a corner, diverging from the otherwise rectangular building to run parallel to the house.

"We were really just testing the waters," Fung says of an approach that would ultimately come to define the five-year project, establishing a sense of harmony between the man-made structures and the gently undulating landscape. In the main house, this guided how they opened up the interior while preserving the post-and-beam construction typical of the era. The house was extended and reconfigured to make room for a larger kitchen and to re-envision three en-suite bedrooms having direct access to the surrounding woodland, including from a private outdoor shower in the primary suite.

It was a process that Fung characterizes as a "collaboration" with Straub and the site, one which was developed further when the architects were asked to design a guesthouse, library and pool house. "At that point, we created the master plan," Fung says, explaining that they used the existing house to create a grid system on which the new pavilions were constructed. The form of the striking Brutalist-style pool house, for example, was informed by the orientation of the house, "but we also had to break from that so we could follow the landscape," she says. As a result, in the guesthouse, there is another play of levels that allows the built-in cabinetry and banquette in the entry space to extend to become a desk in the higher bedroom area. "There's a real flexibility in the estate," Fung says. "It allows for a lot of variety in your experience of the landscape—it's just a very exciting place to be."

(right) The Blodgett-Calvin residence is a prime example of mid-century modernism. The current owners originally considered razing the property and building anew, before eventually deciding to remodel and expand it into a series of understated pavilions.

(left) Blodgett's ceramics studio, originally a garden pergola, was the first in a series of commissions that connected the owners to the architecture firm Fung+Blatt. When viewed from outside, the studio's wraparound shelves make the structure look like a display vitrine for Blodgett's creations.
(below) A view from the pool house, which features a butterfly roof, a library, a gym and a spa, and was built on the same geometric grid as the main house.

(KAZUNORI HAMANA, JAPAN)

SEASIDE STUDIOS: A potter's portfolio on a quiet peninsula.

WORDS Selena Takigawa Hoy PHOTOS Yuna Yagi

The first home that Kazunori Hamana bought is perched on the hillside above the Pacific Ocean, on the Bōsō Peninsula of Japan. The water is just a few dozen meters below, close enough that you could scramble through the brush and jump in.

Hamana often does just that. "I quit being a professional fisherman, so I just cast my net and eat what I've caught on the spot," he says. He's friendly and suntanned, with a frank manner and few airs. He's also a ceramicist whose elegant, hand-built pots grace galleries from Tokyo to New York. But Hamana himself prefers to stay home, puttering between the three properties he owns in this area.

He built this first house 20 years ago, having settled in Chiba following a childhood spent in Hyōgo Prefecture, a stint in the US and some time in Tokyo. Blocks of clay are stacked by the front door and the walls are covered with drawings. Carved Okinawan figures crowd the shelves. Overhead, a fan spins in the rafters. Though he lived here for a time, the house now serves as his main studio.

He creates his pots in an open-plan living room on a scarred dining room table, next to a collection of plum wine jars that are mid-ferment. Hamana works with the sliding glass doors open, awash in sea air. The doors lead out onto a wraparound deck, where his pots—*tsubo* in Japanese—congregate like seaside vacationers. "When I make things by the sea, the horizon is there; it's breathtaking," he says. "Moving water reminds me that the earth is alive, and I'm constantly awed by it."

The pots have brought him international recognition, but he insists that both the pots and the fame are incidental. "For me, what was created is not art; but that hot feeling I get in the background while I'm making it is the essence of art. This," he says, indicating a pot, "is the result."

Hamana bought a nearby farmhouse, his current residence, four years ago. Like much of rural Japan, Chiba Prefecture is suffering from depopulation, and there are more empty houses than willing residents. Hamana studied agriculture when he was younger and had wanted to try rice farming, but had no money to rent or buy a field—until his pots started to take off. At the farmhouse, he's torn out the interior walls to make a big living room. Here, the windows open onto views of his rice fields, which he works himself. "It's so hard," he admits. "I'm out there crying, getting stung by horseflies every 10 meters."

Still, he'd much rather be here than in the city. "I like places that are not surrounded by concrete, but with cicadas buzzing or birds singing.... People made rice fields for hundreds of years and cultivated them and took care of the mountains. I want to live while feeling the relationship between people and nature," he says. "The reason I don't accept apartment blocks is because time stops there. There is no nature, only 'now.' If there's only 'now,' it feels lonely."

Hamana's third property is a work in progress. This farmhouse—more than two centuries old—is in a state of gentle decay, and for now, he's letting it be because he doesn't want to change its mysterious atmosphere. The walls are black, he points out, from the smoke of many hearth fires, and some guests think it's scary. For Hamana, it's history. "It doesn't get this black in a week. It takes a very long time," he says. "I can interact with all that: nature, the earth, the past. A common sentiment with people I've never met who lived hundreds of years ago."

Hamana wants us to consider why we are alive. "If it's only about convenience or efficiency, we should just die. Because that would be most efficient. "That's why I disavow apartment blocks, and air-conditioning always at 26 degrees [Celsius]. I wasn't born to be convenient and live on convenience-store meals," he says. The natural rhythms of life are an integral part of his artistic process, as are farming, fishing and putting his hands in the clay. They are all inseparable parts of his work. "To put it simply," he says, "I want to live while being inspired."

(above) Hamana dries his pots on the terrace of his seaside studio. He also uses the balcony to dry *umeboshi*—the pickled plums he makes every year.

KINFOLK

(right) The walls at Hamana's farmhouse are blackened from centuries of soot from an open hearth. Most developers would have demolished the property, which Hamana bought for the price of the land, but he says he appreciates its simplicity.

(CATH & JEREMY BROWN, UK)

RURAL SPLENDOR:
A farmhouse turned studio bordering a rugged moor.

WORDS
Rosalind Jana
PHOTOS
Alixe Lay

Cath and Jeremy Brown moved their family from London to Devon in 2016, leaving jobs as an architect and at the UN, respectively. There, after buying a secondhand pottery wheel, they set themselves a challenge: to make a 20-piece dinner set for their first Christmas in the countryside. Through trial, error and sheer will, they managed it. Soon after, Feldspar was born: a ceramic and homewares company specializing in elegant, textured pieces ranging from coffee cups to butter dishes. After outgrowing their on-site barn and undergoing a stint firing using the kiln in Jeremy's mother's garage, they now have two workshops.

"We're always trying to capture the naivety of the original idea."

ROSALIND JANA: How would you describe your home's character?

CATH BROWN: Wonky.

JEREMY BROWN: It's quite an eccentric house. Nothing's parallel. It's inspired our products because there are no straight lines.

CB: It's got thick cob walls and a thatched roof over half of it. Then, about 150 years ago, they turned [the other] half into a Georgian-style farmhouse.

RJ: You began Feldspar by creating objects you needed in your own living space. Is that still how you work?

JB: We've been requested by royalty to make stuff. We said no because *we* have to want it.

CB: Yeah—I'm not sure about a gravy boat.

JB: We're just finishing up our wood workshop. It'll have the same ethos, but different materials. We'll start casting our own brass components. We've made a clothes dryer and the table that we're sitting at, and the chairs. Now we're making a cheval mirror—one of those tilting mirrors with little caster wheels, so you can pull it around.

CB: We get obsessed with details that you don't always see in the finished thing.

JB: We can keep the same language going [all over] the house. With our ceramics, we tried to make everything tactile, so that it's nice to hold. The woodwork is similar. . . . Everything has to be a little bit wrong. We're always trying to capture the naivety of the original idea.

RJ: Am I right in thinking you've used clay from your garden in some of your ceramic pieces, too?

CB: We just dug up a flower bed and processed it.

JB: That wasn't fine bone china. It was a mix of china and terra cotta, so it was a burnt orange color. Once they sold out, we didn't make more. But when we're [building] our final house, the ideal thing is when we're digging up the foundations, we'll keep all the clay from that if it's on a seam.

RJ: So you have this vision of a future home built from the ground up, where you've created every single part in conversation with each other?

JB: Cath's background is architecture. It'll be quite modern: smaller, more efficient, every detail considered.

CB: It'll be filled with bizarre objects. We seem to accumulate them from antique shops and relatives. We were given a Victorian egg coddler by a friend who's a silver dealer. It's got all these little containers. You put fuel underneath, so you can boil eggs at the table. We took that idea and made egg cups that have lids on them.

JB: The vision for Feldspar [more generally] is to imagine buying 50 acres of land to build our house, but then also build these Willy Wonka–like studios. There'll be lots of different workshops: for ceramics and woodworking and metal, and there'll be a mill for processing fabrics, a labyrinth of greenhouses for botanicals, glassblowing.... I like the idea of having all these craftspeople, all these different disciplines.

(right) The Feldspar crockery in the foreground is made of fine bone china in Stoke-on-Trent in the British Midlands. The city is known as "The Potteries" because of its 300-year-long association with the industry.

(left) Cath and Jeremy Brown previously lived in London, although Jeremy spent a lot of time abroad working with the UN on implementing ethical supply chains in the fashion industry. During a period of burnout, Jeremy began to read craft books and the idea for Feldspar was born.

(left) Thatch was once the predominant form of roofing in rural Britain, however it is rarely used in new buildings. In London, thatched buildings have been banned since 1212 because of the perceived fire risk.

INTERIORS

(JORGE PARRA, SPAIN)

FADED GRANDEUR: Peeling back the layers of a scenographer's palatial suite.

WORDS Agnish Ray PHOTOS Marina Denisova

When he installed his apartment and studio in an 18th-century palace in the Madrid town of Aranjuez, the creative director and scenographer Jorge Parra had no interest in masterminding a contemporary revamp. Instead he chose to amplify the antique, sometimes crumbling history of the place. With peeling wallpaper, unfinished surfaces and a hodgepodge of furniture that testifies to the Spanish aesthete's eye for a good auction find, the home exudes eclectic opulence. Parra's pajama-inspired clothing label, House of Bows, encourages nostalgic dreams of days gone by and his decadent home invites visitors to indulge in the same.

AGNISH RAY: How'd you end up living here?
JORGE PARRA: The Medinaceli Palace was built in the mid-1700s. My ancestors were related to the Medinaceli family, so this palace came to them during a distribution of inheritance. When I returned to Madrid from living in Berlin, Oporto and Barcelona a few years ago, I set up my apartment in what were once the game rooms of the palace.
AR: Did you consider giving it a fresh, modern makeover?
JP: It's in a state of decay, which is what I like. I like things that are so beautiful that they remain beautiful even when they're dying; I want to preserve that eternal beauty. A new house doesn't interest me.

AR: How did you give the walls such incredible texture?
JP: I peeled away at years' worth of wallpaper by hand, using a spatula. I dampened the walls with hot water and as I took one layer off, there was another underneath, and another, until I was finally left with this. One of the wallpapers, with a fleur-de-lis pattern on it, must have been from the original palace.
AR: What else feels like it's crumbling?
JP: Some of the original window frames are half-broken and I love the crackled texture of the painted wood. In one of the rooms I had the ceiling painted: They did such a bad job, it was left peeling off but I loved it, so I left it like that. In summer, when it's hot, pieces sometimes fall off from above. My friends think I'm crazy, but when they come over they all agree that it looks great.
AR: If you're having people over, how do you set up the dining room?
JP: The table is laid with a classic white embroidered tablecloth, a vase with colorful flowers, porcelain dinnerware from Limoges and antique silver cutlery. The house smells like a mix of tobacco, jasmine and incense—aromas like oud, amber and palo santo.
AR: Who's your dream dinner guest?
JP: The American art collector Gertrude Stein.
AR: You're something of an art collector yourself. What are some of your highlight pieces?

JP: An original 1802 Goya print from his bullfighting series and two original sketches by the French playwright Jean Cocteau.
AR: Your tastes reflect a romantic gaze toward the past. Which era do you feel you most belong to in terms of style and design?
JP: I adore Palladian architecture. But I also love the 1920s which were an aesthetic revolution from start to finish, with Bauhaus as the icing on the cake.
AR: You inherited the property from your family. Is the theme of inheritance reflected in the decor?
JP: Yes, I inherited lots of the furniture, like an 18th-century Louis XVI-style writing desk made of palo santo wood, which smells incredible. My grandmother used to keep lots of inherited pieces as well as antiques bought in France and Belgium, so I've been obsessed with furniture since I was little, particularly seats.
AR: Where do you most like to sit?
JP: On a 19th-century green-and-white chaise with original silk upholstering, which I keep in the reading room; I got it from my friends' interiors studio, Casa Josephine.
AR: Why do you think you steer toward old, inherited and found pieces?
JP: Because antique handmade pieces have a soul. An artisan made that stool by hand, so it has an energetic significance; it's important to show it deference.

(below) Alongside running his fashion label, House of Bows, Parra works as a scenographer. The two passions often collide; several decorative items in his apartment, such as the papier-mâché Salvador Dalí bust on page 164, were originally props for *Monsieur JPL*—a short promotional movie he created for the brand.

WORDS Ricci Shryock PHOTOS Dà Silvio Nkouka-Bizenga

(ONDINE SAGLIO, SENEGAL)

HERITAGE CRÆFT: A colorful guesthouse decorated by the artists of Gorée Island.

The ferry ride from Dakar to Gorée Island is one of the highlights of a visit to the ASAO guesthouse. "On the boat I feel like I am in heaven," says Ondine Saglio, who has owned the house with her mother since 1989 and has operated it as a guesthouse since 2010. "You leave the crazy traffic noise of Dakar, you put one foot on the boat and you feel like you're going back to paradise."

That paradise for Saglio is where she spent the first seven years of her life. Today, even though she lives in Paris, she says she still feels most at home on Gorée. Her passion for the place is one reason she and her mother, Valérie Schlumberger, bought the home, located on a side street just a block away from the island's main beach.

"The spirit of the house is an old house," Saglio says of the colonial-era property. "It's very simple, but very beautiful. My mom kept it the exact same way. She wanted to keep the spirit, which she did, but she changed a lot of decorations."

Most of those decorations come from working with local artisans and associations such as ASAO (Association for Senegal and West Africa), which Saglio founded. A sheet featuring a flying bird—locally sewn from bright orange and yellow wax fabric—covers one bed. Colorful *sous verre*–style paintings done on glass, an artistic tradition in Senegal, line the walls. Wooden panels from an old Dakar cinema demarcate different spaces. Schlumberger also built a terrace and improved the garden, where birds are heard singing most of the day.

Guests can stay in one of seven bedrooms, each with its own style. One room is painted white with green polka dots; in another, red earth–tinted walls complement pieces by Senegalese sculptor Moussa Sakho.

Gorée was once the largest slave-trading center on the west coast of Africa, and today there are museums that mark its violent past. There are also residents living vividly in the present: Children swim at the small beach where the ferry boat arrives, and restaurants serve up grilled fish and ginger juice.

Saglio stresses that the guesthouse is meant to be an integral part of the community, so a large portion of the profits are donated to Keur Khadija, a nearby center offering support and education to children. "It's connected to the community," she says. "It was built by the community. It was restored by the community. And the money goes to the community."

(left)　　　　ASAO, an organization that Saglio's family established, makes furniture, fabric products and embroidery. The house's decorations are a mixture of vintage pieces and products from ASAO.

IV

178 — 192

DIRECTORY
On feedback, philosophy and vanlife.

178	Peer Review	185	Last Night
179	Object Matters	186	Emanuele Coccia
180	Behind the Scenes	188	Cult Rooms
182	Crossword	191	Stockists
183	Correction	192	My Favorite Thing

PEER REVIEW

Words:
Laurs Kemp

Upcycle designer LAURS KEMP on the influence of mid-century salvage artist LOUISE NEVELSON.

As a child, my favorite toys were fabric scraps. I would wrap them around myself, imagining they were elegant gowns, until it was time to return them to the toy box. That box of scraps hummed with possibility, and my reverence for it belied its humble contents. The real-world applications for this practice, in art and design, would not become apparent to me until years later.

The relationship between found materials and final output can be well studied in the sculptures of Louise Nevelson. Born in 1899, she lived a life nearly parallel to the 20th century. Her family emigrated from what is now Ukraine to Rockport, Maine, when Nevelson was six years old and, though she learned English in school, she spoke Yiddish at home. Her father operated a junkyard, salvaging scraps from around the neighborhood. Nevelson studied sculpture and painting, and had her first solo show at New York's Nierendorf Gallery in 1941, where her use of found materials—a shoebox, for example—was greeted with largely dismissive reviews.

Then in 1954, when her New York neighborhood of Kips Bay was slated for redevelopment, she gathered architectural scraps from demolished buildings, as her father had done decades earlier. By arranging these scraps into assemblages and spray-painting them monochromatic black or white (later, she added gold to the repertoire), Nevelson stripped them of their intended purpose and produced otherworldly sculptural installations. Her cubist leanings helped give them shape. Toward the end of the decade, when Nevelson was approaching 60, her career finally took off. She presented at MoMA's *16 Americans* group show and at the 31st Venice Biennale and made her first museum sale to the Whitney.[1]

Her sustainable ethos is of particular interest to my mode of post-consumer fashion design. Much like Nevelson, upcycle designers navigate the strictures to recontextualize and elevate found materials. Appreciation of a finished work can deepen when its unassuming origins are revealed.

(1) Viewing *Dawn's Host* at Stockholm's Moderna Museet, I finally became what I had previously only socially performed in art museums: enraptured. The work is made up of wood scraps, arranged on a large disc, propped vertically atop a plinth, painted white and shrouded in mystery—the overtness of its quotidian components shrugged off in service to the whole. Is it an ancient monolith? An alien obelisk? It was created as part of a larger installation, titled *Dawn's Wedding Feast*, for MoMA's *16 Americans* group exhibition. The entirety of that installation filled a room, but even this singular piece retains considerable power.

OBJECT MATTERS

Words:
Rachel Connolly

An unperfumed history of the scented candle.

For a long time, candles were an essential light source, but they weren't particularly appealing as objects. In many early civilizations, candles were made from animal fat and burned with greasy, sooty smoke and a pungent sour smell; during the Middle Ages, several European cities even banned making them because of their polluting qualities. Early Japanese candles were an exception: They were made by boiling the fruit from cinnamon trees, and produced a sweet smell. These were the earliest "scented" candles, but the pleasant odor was merely a side effect of the production process rather than an intended feature. For as long as candles were used primarily as a light source, they remained functional rather than decorative.

Thanks to scientific breakthroughs in the 18th century, particularly the invention of paraffin wax, candles began to smell more neutral. But they were soon rendered unnecessary by the invention of gas lamps, and then electric light in 1879. Over a century later, advances in colored wax and perfume created a candle boom in the 1990s. Since then, their increasing popularity has driven candles steadily into the luxury market.

Candles are now seen as a way to create ambiance in a room: Aroma, in particular, has a transportive quality. It can strongly evoke memories and associations of particular people and places. For a generation who rents and moves frequently, the opportunities for home decoration can be limited, and scented candles are an easy way to make a new room feel personal. Certain scents—geranium and lavender, for example—tend to trigger the release of hormones like serotonin or dopamine and so have a calming effect. For those working from home, an aromatic candle can transform a room back into a relaxing space at the end of the day. The scented candle business has evolved into an industry with as much choice and variety as the perfume world. This feeds a considerable demand: The global market was valued at $533.5 million in 2020. A sweet-smelling success for a once-humble item.

Photograph: Gioncarlo Valentine

BEHIND THE SCENES

Words:
Louise Benson

CLYNTON LOWRY on the art handler's load.

The art market might be extraordinarily lucrative, but there is little thought given to the workforce that keeps its wheels turning.[1] Clynton Lowry, the editor in chief of *Art Handler*, launched the title in 2015 to offer a fresh perspective on the cloistered, often secretive world. Through a mixture of articles and—on Instagram—memes, he lifts the curtain on its cast of super-collectors, highly strung curators and egotistical dealers.

This interview is the first in a new series profiling influential people within the creative industries whose work often goes unseen.

LOUISE BENSON: Why did you start working on *Art Handler*?

CLYNTON LOWRY: I started the magazine while I was working as a studio assistant, and I had previously done art handling part-time. I felt certain that there was an audience for it and that it could be a great resource. I also thought that it would be a lot of fun. *Art Handler* is still the only publication dedicated to this perspective.

LB: How would you describe the profile of a typical art handler?

CL: Many are highly educated and maybe think of themselves as overqualified for the position, but everyone needs to pay their rent. You also get a lot of musicians who play in bands due to the flexible nature of the job. Everyone wears a lot of hats in the art world. As an art handler, you're often installing the work, writing the press releases, packing work and doing the production. It's a huge spectrum expected from each individual.

LB: Why do you think the art world demands so much from its workers?

CL: The art world runs as an industry with its own hierarchy. It is primarily a market in the business of art sales, and then you have the MFA education system, but it's an industry on both ends. It's much smaller in comparison to even other creative industries, like film or fashion. It's very non-standardized, which creates these loose definitions around work and leisure. At what point are you installing your friend's show as a part-time worker, and when is it a collaborative effort?

LB: Can you share any stories of nightmare jobs you've been on?

CL: At a fair in Miami, some art handlers were forced to install works in the dark due to the heat, without any air-conditioning—and with art dealers breathing down their necks on deadline. I can't even begin to imagine what that must have been like. Injuries like falling off a ladder, or between the loading bay and the truck, are also common. Then there's the interpersonal nightmare experience with clients. The strenuous physical nature of the job is very visible but there's also a lot of psychological abuse.

LB: Why do you think the reality of these working conditions is often overlooked?

CL: Larger art publications haven't come forward with a behind-the-scenes perspective because there is a long history of putting the artwork as the focus. It's about the artist, the viewer and the exhibition. That's how it's been done forever. But the main trajectory of artworks is all behind the scenes.

(1) In 2018, art handlers at MoMA PS1 in Queens demonstrated outside the museum to demand the same pay as their colleagues at the Museum of Modern Art mother ship in Manhattan, where workers were paid up to $17 an hour more.

MIS-STATELY HOMES

Crossword: Mark Halpin

ACROSS

1. Bellyaches; grievances
6. Spade, Sneed and others
10. "You said it!"
14. "Network" director Sidney
15. Enjoy a board game, maybe
16. The Nautilus' captain
17. Ciao, elsewhere
18. Tall tale
19. Not at all slack
20. "There's no need to speak of this stately home"?
23. Prior to, poetically
24. Arafat's grp.
25. A lot of bother
26. Mormon church, for short
29. Beaver's construction project
30. Any of several tsars
32. Like a situation at the start of some innings
34. Biblical scene of confusion
36. "____ in the Sun"
37. "Is it chilly in this stately home?"?
40. Syrup sources
41. Foreign representative
42. Pays to play
43. "Auld Lang ____"
44. Chicago airport code
47. Go downhill fast
48. Dreidel, for one
50. Tolkien brute
52. East Asian path to enlightenment
53. Sparring in a stately home?
57. La Scala highlight
59. Migratory seabird
60. Chimney output
61. Young equine
62. Related to a Keats poem, e.g.
63. Cybertruck maker

64. Campground accomodations	13. Sarcastic sentence ender
65. Exclusive	21. Suspects' excuses
66. Malicious expression	22. Dilettante or amateur
	27. Passage for air or tears
	28. Jeanne d'Arc, for one (abbr.)

DOWN

1. Like propellers and cutlery	31. Narrow street
2. Pulitzer winner Welty	33. Skin-care brand
3. Rapper whose name sounds like a candy	34. Bitterness; ill humor
	35. Zoroastrianism's sacred book
4. Parts of a yard	36. Quickly and cleanly, etc.
5. Logging leftover	37. Like a moldy cellar
6. John le Carré offering	38. One who makes many spectacles
7. "Woe is me!"	39. Declare
8. Nottingham Maid	40. More, in Madrid
9. Bishops' gathering	43. Skimpy swimwear brand
10. Against	44. Useless; slothful
11. Dish aka farsbrød or haslet	45. Rub the wrong way
12. Ostrich's smaller kin	—

CORRECTION: FEEDBACK FORMS

Words:
Precious Adesina

Why customer star ratings are so unsatisfactory.

In 2003, American management consultant Fred Reichheld invented a system to measure how customers perceive companies, which he called Net Promoter Score (NPS). The premise was straightforward. Asking one simple question could determine customer loyalty: "How likely is it that you would recommend our company to a friend or colleague?" The more a person was willing to promote a business, the better the chances that they'd return themselves. But over two decades, this simple idea has taken on a life of its own.

Whether talking to an airline, dealing with a delivery service or ordering takeout, customers are now often asked for feedback after each communication. The assumption by a customer filling out these forms is that

their smiley face, number grade or written response will be used to improve the mechanics of the company. But a survey by Accenture-Medallia in 2017 determined that almost half of companies use these ratings to evaluate their front-facing workers, with the results impacting their pay.[1] A financial advisor at one of the top banks in Canada mentioned in an interview with the New York–based magazine *Jacobin* that poor reviews are often based on things that are out of an employee's control, such as wait times, high fees or whether an applicant's mortgage was approved. Unsurprisingly, Medallia also found that employees were 50% more likely to complain that their teammates were asking customers for high scores when pay was linked to these ratings.

For small businesses, feedback has also become less about improvement and more about online presence. Ratings on sites and apps such as Door Dash and Tripadvisor can make or break these companies. Consequently, studies have shown that when customers know that responses directly affect the worker or business they're interacting with, the forms are largely useless—customers are more likely to grade out of sympathy or spite rather than offer a genuine appraisal.

Feedback forms should be a place to communicate with the people in charge—an arena in which David can do battle with the corporate Goliath. More often than not, however, the forms actually pit the customer against those working at the company's lowest levels. It's lonely at the top; even more so if you choose not to listen.

(1) In an article for *The Atlantic*, writer Megan Ward argues that giving feedback is not the same thing as being heard. "Encouraging users to fire off reviews—especially those that have consequences, such as an [Uber] driver's livelihood—turns opinions into information," she wrote. That information gets fed back into the system, and gig-economy workers often suffer the consequences.

LAST NIGHT

Words: George Upton

What did designer FRANCK GAUTHÉ do with his evening?

Franck Gauthé is the founder of menswear brand The Coolest Man You Know and a proud Parisian. Five years after launching a concept store in the heart of the city in 2015, Gauthé started his own label, focusing on well-made clothes with low environmental impact.

GEORGE UPTON: What did you do last night?
FRANCK GAUTHÉ: I was with a friend at our favorite Indian restaurant in Paris, Azaytoona, in the 18th arrondissement. I got home pretty early and spent the evening working.
GU: Do you like working at home?
FG: Yes; I'm a homebody. I've made a place for myself that has a really nice vibe, and everything I need is here. I can be creative at home.
GU: When was the last time you stayed up all night?
FG: Two days ago. My mind is clearer at night and I didn't have much to do the next day, so I stayed up working on our new collection.
GU: Do you find it easy to switch off from work?
FG: I cut from work when I have my kids with me, but to be honest, most of the time I never completely switch off. I do pretty much everything with the brand and there's a lot to think about. It's my passion, though, so it's not really work for me.
GU: What's your bedroom like?
FG: It's very minimal. I have a mattress on the floor with a nice painting above it and a vintage bench at the foot of the bed with lots of plants. I'm lucky enough to have my closet in a separate part of the apartment, so it's a pretty simple room. There's something special about it—it's where I go when I want to focus or relax.
GU: What would be your ideal night in Paris?
FG: My friends and I are restaurant people—it's how we spend a lot of our time together. The perfect evening would be to meet my friends at a restaurant that we want to try out and perhaps go on to somewhere else before cycling home, taking my time. Nothing beats the vibe of Paris in the evening, especially in the summertime.

DIRECTORY

EMANUELE COCCIA

Words:
Stephanie d'Arc Taylor

An interview with fashion's favorite philosopher.

Listening to philosopher Emanuele Coccia speak, you'd think he belongs more in a Voltaire play, or perhaps a chiaroscuro Renaissance painting, than in modern life. But his Instagram shows him in oversized glasses, and features cars, computer keyboards and other newfangled contraptions that place him firmly in the 21st century.

A doctor of medieval philosophy, Coccia has more recently focused on the theory of fashion. He's produced a photo book with the Dutch fashion photographer Viviane Sassen, and is currently working on another with Alessandro Michele, his friend and the creative director of Gucci. Where are the intersections between his two worlds?

STEPHANIE D'ARC TAYLOR: What is philosophy to you?

EMANUELE COCCIA: Etymologically, the word *philosophy* contains the idea that knowledge is not produced by a school but by love, by passion. It's strange to look at the collection of texts we consider philosophy. You have literary books like Plato or treatises on economics like Marx or poems like Lucretius. The form of expression is constantly changing. The only way to define philosophy is that it's a knowledge that is different from others because of the way it arises. You're so obsessed by the desire to know something and the love for something, that the knowledge you acquire doesn't belong to you anymore. Like a lover doesn't belong just to themselves anymore, but also to their lover. Philosophy is knowledge under the power of love. It's a New Age definition, maybe, but it's the only possibility.

SDT: What is art?

EC: In antiquity, there was a division of activities we now know as art. The liberal arts were the technology of freedom. The people who partook didn't have to work to survive. These were activities that were supposed to intensify your freedom. The other activities—painting, theater, sculpture—were called the mechanical arts and were done by slaves. These arts were not allowed to be practiced by free men until the Renaissance. At that point, some artists claimed that by manipulating matter physically you can, in a way, intensify your freedom. The definition of art is exactly that.

SDT: What drew you to the fashion world?

EC: When I moved to France for the first time, I became close friends with Azzedine Alaïa and Carla Sozzani, the sister of the former director of *Vogue Italia*. From there I came in contact with a lot of fashion designers and photographers, and this changed everything for me. In Europe for a long time fashion wasn't considered an important part of culture. When I teach fashion classes at universities, people look at me as if I am stupid or frivolous. Nothing evokes a stronger emotion in me than a good catwalk. It's animated artwork. Fashion is the laboratory of new moral identities. A garment is the most universal artifact that we produce. Everyone wears clothes all day every day. Everybody has this artifact to express their identities. Fashion is the space of self production.

SDT: What does it mean that humans are the only animals to wear clothes?

EC: Insects change their skins through metamorphosis. When a caterpillar changes into a butterfly, it's also a form of fashion; evolution is a phenomenon that is very close to fashion. If you think of a peacock's tail, the pattern has been chosen by the female, on the basis of an aesthetical judgment.

SDT: Philosophically speaking, how does fashion describe the world?

EC: Fashion doesn't just describe the world, it also produces the world. It's an impulse to change what you wear and simultaneously make comments on social norms. Every time we witness a new entry in fashion it means the world is now changed. Look what happened with the introduction of the miniskirt or the tuxedo jacket. It's opening up a new possibility. In fashion you can't just represent yourself, you have to change something every time, otherwise you're just a sartorialist. Good designers forever change the way we look at our daily life. A garment is the first contact between us and the outer world. Let's take, for instance, Alessandro Michele, the director of Gucci. The very first collection he designed in 2015 was heralded as the first true gender fluidity in fashion. Consider the bow tie in that collection. Historically this is a very important tie: It's supposed to be the tie that the mistress of Louis XIV took from the body of the king and put on herself. Michele produced shirts for men with that same tie. Through this he said *now men are obliged to take the symbols of power from the feminine silhouette*. This was the deconstruction of a centuries-old system.

CULT ROOMS

Words:
Louise Benson

ALBERTO ROSSELLI's Mobile House presaged "vanlife" half a century ago.

"Nothing behind me, everything ahead of me, as is ever so on the road." This hopeful vision of a new way of life is the thread that runs throughout Jack Kerouac's 1957 novel, *On the Road*. Fifteen years later, Italian architect and industrial designer Alberto Rosselli would give practical shape to this countercultural trend for nomadic living with his design for the extendable Mobile House.

Rosselli's design—introduced at MoMA in 1972 as part of a major group exhibition *Italy: The New Domestic Landscape*—could triple in size thanks to telescoping runners, hinged floors and accordion walls that allowed it to extend in four directions. Sleek in silver, it carried all the hallmarks of the futuristic design of the period, from the rounded doors and circular, periscope-like windows to the shiny molded plastic seats and furnishings.

This was by no means the first RV—the Airstream had emerged as early as 1931, while the iconic VW campervan followed in 1949—but it was certainly the most comfortable. Integral to Rosselli's design was a consideration of how it might be possible to re-create the relaxing experience of a real home while embracing the flexibility of life elsewhere. As he put it: "One's dimensions must not be conditioned by transport necessity."

"Rosselli revised the typology of caravans and introduced a new type of pop-up trailer," says Mathias Schwartz-Clauss, former senior curator at the Vitra Design Museum and author of *Living in Motion: Design and Architecture for Flexible Dwelling*. "With his 'Mobile House,' he responded to the interest of a young generation of consumers in unconventional, autonomous forms of living and applied the increasing prestige of an industrial design with its uniform contemporary look to the model of new types of unfolding spacecrafts."

Born in Palermo in 1921, Rosselli had made a name for himself in his home country by founding the magazine *Stile Industria* in 1954; entire issues were dedicated to a single object—everything from curtains to electronic calculators. Contributors included the likes of Bruno Munari, Enzo Mari and Max Huber.

Rosselli's decade-long editorship of the magazine reflects just how well he understood the ways in which the objects that we unthinkingly surround ourselves with can impact our lives. During the 1950s and '60s, he designed everything from a hair dryer to a gas boiler, a coffee machine to bathroom units, for leading Italian brands of the period including Kartell, Fiat and Pavoni.

A five-minute film of Rosselli's campervan of the future, produced for the MoMA exhibition, brings this vision vividly to life. Set to Pink Floyd's hazy guitar riffs, two svelte couples unpack and expand their mobile home in the midst of a forest clearing before lounging in its stylish mid-century modern interior with drinks and magazines.

This romantic vision feels of a piece with today's "vanlife" culture. Vanlife, as *The New Yorker* describes it, "is a one-word lifestyle signifier that has come to evoke a number of contemporary trends: a renewed interest in the American road trip, a culture of hippie-inflected outdoorsiness, and a life free from the tyranny of a nine-to-five office job."

Fittingly, images of Rosselli's design for mobile living now circulate online on Pinterest and Tumblr, while effusive headlines name it "genius" and "the world's coolest forgotten camper." It is also often mislabeled in internet searches, which confuse Rosselli's campervan with Dutch architect Eduard Böhtlingk's De Markies, an expandable caravan built in 1986.

A resurgence of interest in Rosselli's design could be connected to the recent explosion in popularity of tiny houses and to current economic conditions: House prices in the US are 860% higher in 2022 than they were in 1967. That consumers are looking to downsize today reflects less of the youthful optimism that imbues Kerouac's classic tale and more of a difficult necessity.[1]

The Mobile House was never put into production following the prototype, yet its continued appeal lies in Rosselli's evocative blend of heady utopianism mixed with real-life pragmatism. The playful design remains a prescient paean to new technology, alternative forms of living and the open road.

(1) The award-winning 2020 movie *Nomadland*, in which Frances McDormand plays a widow who travels around the US in a van, brought into wider consciousness the economic upheaval and social dislocation that often drives people out onto the road.

OUT NOW
The latest travel book from *Kinfolk*

Kinfolk Islands marks the start of an exciting new series of titles with Artisan Books that foster thoughtful perspectives on the places we visit. Join us on a journey off the beaten track, to islands big and small, in this collection of 18 new travel stories.

Order now at Kinfolk.com

STOCKISTS:
A — Z

A	A-COLD-WALL*	a-cold-wall.com
	ASAO	asao.fr
	AURALEE	auralee.jp
C	CARL HANSEN & SØN	carlhansen.com
	CASASOLA	casasola.co
	CECILE TULKENS	ceciletulkens.com
	CHARLES DE VILMORIN	charlesdevilmorin.fr
D	DRIES VAN NOTEN	driesvannoten.com
F	FELDSPAR	feldspar.studio
G	GIULIVA HERITAGE	giulivaheritage.com
H	HELMUT LANG	helmutlang.com
	HENRIETTE H	henrietteh.com
	HERMÈS	hermes.com
	HOUSE OF BOWS	houseofbowsjpl.com
	HOUSE OF FINN JUHL	finnjuhl.com
I	ISSEY MIYAKE	isseymiyake.com
J	JIL SANDER	jilsander.com
K	KALLMEYER	kallmeyer.nyc
L	LORO PIANA	loropiana.com
M	MARSET	marset.com
	MAX MARA	maxmara.com
	MENU	menuspace.com
	MOLLI	molli.com
N	NOMASEI	nomasei.com
O	OMEGA	omegawatches.com
P	PAUL SMITH	paulsmith.com
	PRADA	prada.com
S	SILK LAUNDRY	silklaundry.com
	SPORTMAX	sportmax.com
	STELLA MCCARTNEY	stellamccartney.com
	STRING	stringfurniture.com
T	TIBI	tibi.com
	TINA FREY	tf.design
	TINY COTTONS	tinycottons.com
	TORY BURCH	toryburch.com
	TRESSÉ	tresse-paris.com
V	VIPP	vipp.com

MY FAVORITE THING

Words:
Daphnée Denis

CHARLES DE VILMORIN, interviewed on page 78, on the possibilities of a sewing machine.

For me, a sewing machine represents the most absolute means of expression—like a third hand. It's an object I adore because it renders so many things possible. It's where everything comes to life. I tend to change sewing machines from one project to the next because I find myself sewing very thick pieces of padding or other fabrics, and I always end up breaking them. I've gone through six or seven since I started studying fashion, so I always pick the cheap ones. I like this sewing machine specifically because I painted on it. It appears in the film for my spring–summer 2022 couture collection, where a little boy starts crafting pieces with it. I never owned a sewing machine before I was accepted into the Chambre Syndicale de la Couture Parisienne, but I taught myself to use my grandmother's sewing machine when I visited her. I made costumes and theater decor. Because I don't work off patterns or take measurements, my sewing machine really is the one object that helps me turn my vision into reality. It means absolute freedom—except when it breaks, which is the most unbearable thing that can happen.